Collins easy learning

Mandarin Chinese Characters

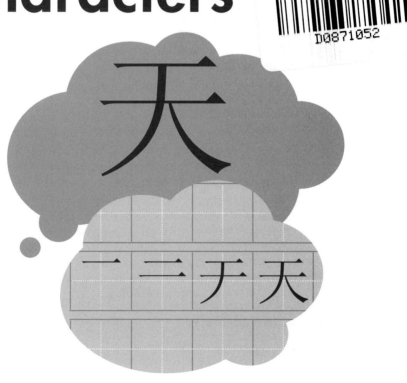

Published by Collins
An imprint of HarperCollins Publishers
Westerhill Road
Bishopbriggs
Glasgow G64 2QT

Second Edition 2017

10 9 8 7 6 5 4 3

© HarperCollins Publishers 2012, 2017

ISBN 978-0-00-819604-2

Collins® is a registered trademark of
HarperCollins Publishers Limited

www.collinsdictionary.com

Typeset by Davidson Publishing Solutions,
Glasgow

Printed in China by RR Donnelley APS

If you would like to comment on any aspect
of this book, please contact us at the given
address or online.
E-mail: dictionaries@harpercollins.co.uk
facebook.com/collinsdictionary
@collinsdict

Acknowledgements
We would like to thank those authors and
publishers who kindly gave permission for
copyright material to be used in the Collins
Corpus. We would also like to thank Times
Newspapers Ltd for providing valuable data.

WRITTEN BY
Kester Newill

FOR THE PUBLISHER
Maree Airlie
Gerry Breslin
Freddy Chick
Kerry Ferguson
Lisa Todd

MIX
Paper from
responsible sources
FSC™ C007454

FSC™ is a non-profit international organisation established to promote the
responsible management of the world's forests. Products carrying the FSC
label are independently certified to assure consumers that they come from
forests that are managed to meet the social, economic and ecological needs
of present and future generations, and other controlled sources.

Find out more about HarperCollins and the environment at
www.harpercollins.co.uk/green

Contents

Hello

Welcome to *Collins Easy Learning Mandarin Chinese Characters*!

Have you been studying Chinese for a while, and want to focus more of your efforts on learning characters?

Are you planning to visit China soon, and would like to be able to understand some of the most common characters that you will see all around you when you're there?

Would you like a taste of one of the oldest writing systems in the world?

If you answered 'yes' to any of these questions, then this book is for you.

This book explains how Chinese characters are constructed, breaking them down to components that are shared by many common characters. You will find out how characters use these components to communicate meaning and sound, and you will be shown how to write the characters stroke-by-stroke.

If you're coming to Chinese completely from fresh we recommend you read the introduction fully before starting out on the characters. It offers a brief background to the Chinese language and lays down some ground rules for stroke formation and Pinyin pronunciation that will be essential to your progress.

The Chinese language

Chinese characters

The Chinese script has a written history that goes back over three thousand years. In China, an educated person will know roughly 4000–6000 characters. A knowledge of about 3000 characters is generally considered sufficient for basic literacy (newspapers and the like).

Each of these characters has to be learnt individually – and the shape of the character, the sound of it and the meaning are learnt together as a unit. There is no way of predicting the sound and meaning of an unknown Chinese character with complete accuracy. This does not mean, however, that there is no system behind the characters at all.

To the uninitiated, Chinese looks bewildering, and you may be asking yourself, how on earth do Chinese people learn thousands of different characters?

Here are a few principles to bear in mind:

- *All Chinese characters are made by combining one or more simple components.*
 There are only a few hundred basic components that are put together to
 make up all the thousands of characters in use. Admittedly, a few hundred
 components may sound like a lot, but hopefully you will now be realising that
 the task is a lot more manageable than you thought!

- *Some of these components look like objects in the world.*
 You may have to have this resemblance pointed out to you, but once you
 know, they are quite easy to remember.

- *Some of these components can help you predict what the character means.*
 These are called **radicals**. If you are familiar with these it will also help you
 identify more of the building blocks of the characters you are trying to learn.
 Although the radical of a character is not always a reliable guide to the
 character's meaning, some are more dependable than others. For example,
 things containing the **rain radical** 雨 almost always have something to do
 with the weather, and things containing the **heart radical** 心 are generally
 something to do with feelings and perceptions. You will learn more about
 these as you progress through the book.

- *A few components can even help you predict what the character sounds like.*
 These are called **phonetics**. Occasionally, the sound of the component
 matches quite closely how the character itself sounds. But more often than
 not, as Chinese has developed over a long period of time, the phonetic is now
 just a rough indication: the vowel sound might be similar, or the consonant
 sound might be similar. You will find examples of phonetics throughout
 the book. Phonetics are an often neglected aspect of learning Chinese. We
 think you will find it interesting to see these underlying aspects of Chinese
 character development, and it will help you to make some links between
 characters in your mind. The more links you make between characters,
 the easier they become to remember.

These are the principles that Chinese people themselves use. When Chinese
children learn to read and write, they frequently come across characters they
have never seen before. But, they are able to 'read' the character. They start by
identifying the basic components that make up the character, and then use
their experience of these principles to make rough – but logical – guesses about
the meaning and sometimes the sound of the character.

This book will help you develop this skill of 'reading' a character, and let you start
to appreciate characters as if through the eyes of a Chinese person. As you work
through the book and gain confidence and knowledge, you will be able to start
making logical guesses as to meaning and sound when you come across a new
character.

Traditional / simplified forms

The government of the People's Republic of China carried out a programme of simplifying the Chinese script in 1956 and another in 1964, in an effort to improve the literacy rate by making characters easier to write. However, for various cultural and political reasons, many regions outside the PRC did not accept these changes, and continued to use the old system. Taiwan still uses traditional characters, as do Hong Kong and Singapore. Overseas Chinese communities have tended to use traditional characters, though that may change in the future as the changes that are taking place in mainland China make it much easier for people to come to the West for work or study.

Writing Chinese

Basic strokes

Every Chinese character is made up of strokes and these are written in a set way. It is important to practise these as it will make writing any Chinese character easy and will help when looking up characters in the dictionary.

The table below shows the basic strokes and some strokes with hooks and turns.

Stroke	Direction	Examples
dot	↘	六 主 文
horizontal	→	三 干 上
vertical	↓	十 开 千
downward stroke to the left	ノ	人 为 发
downward stroke to the right	↘	木 大 夫
rising stroke	↗	拉 习 状
hooks	↓ → ↳ ↳	丁 买 找 心
turns	↳ ↲ ↱ ↳	山 女 马 云

Stroke order

Each of the strokes in a Chinese character is written according to rules. These rules not only ensure the characters look correct but also make them easier to learn. After a while writing characters will become second nature and you will write them correctly without having to think about the order in which the strokes come in.

The general rule for writing Chinese characters is to write from top to bottom and from left to right. This is simple with characters such as 三 **sān** (three) or 川 **chuān** (river) as shown below.

三 **sān** – three 　　　　　二 三 三

川 **chuān** – river 　　　　川 川 川

If there is more than one component to a character then each component should be completed following the above rule.

For example the character 爸 **bà** (father) is made up of the top component 父 and the bottom component 巴. First of all you would write the whole of the top component 父 and then the bottom component 巴 as shown below.

爸 **bà** – father 　　　　　爻 爸

Similarly the character 和 **hé** (and) is made up of the left component 禾 and the right component 口. Therefore, you would first write the whole of the left component 禾 and then write the component on the right 口.

和 **hé** – and 　　　　　禾 和

However, there are a number of exceptions to this rule and some of these are given below.

1 　Horizontal strokes are written before vertical strokes.

　　十 **shí** – ten 　　　　　十 十

　　千 **qiān** – thousand 　　　千 千 千

2 　Left falling strokes are written before right falling strokes.

　　人 **rén** – person 　　　　人 人

　　文 **wén** – writing, language 　文 文 文 文

Writing Chinese

3 Left vertical strokes are written before top horizontal strokes.

口 **kǒu** – mouth 冂 冂 口

日 **rì** – sun 丨 冂 日 日

4 Bottom horizontal strokes are written last.

王 **wáng** – king 王 王 王 王

由 **yóu** – cause, due to 丨 冂 由 由 由

5 Centre strokes are written before outside strokes.

小 **xiǎo** – small 小 小 小

水 **shuǐ** – water 水 水 水 水

6 Crossing strokes are written last. This can be a vertical crossing stroke as in:

中 **zhōng** – centre, China 丨 冂 中 中

or a horizontal stroke as in:

母 **mǔ** – mother 母 母 母 母 母

7 Minor strokes are written last.

玉 **yù** – jade 玉 玉 王 玉 玉

发 **fā** – to send 发 发 发 发 发

8 Enclosing strokes are written before enclosed strokes.

同 **tóng** – same 冂 冂 同 同 同 同

月 **yuè** – moon 月 月 月 月

9 Bottom enclosing strokes are written after enclosed strokes.

这 **zhè** – this 这 这 这 这 这 这 这

凶 **xiōng** – unlucky 凶 凶 凶 凶

10 First outside, then inside and "close the door".

This refers to characters that have a box, i.e. they have strokes on all four sides. With such characters you must first write the strokes that make up three sides of the box, then fill in the contents of the box before finishing off the box with the lower horizontal stroke, or "close the door" as it is referred to in Chinese.

国 gúo – country

国 国 国 国 开 国 国 国

园 yuān – garden, park

园 园 园 园 园 园 园

There are exceptions to these rules too so it is important to watch teachers and Chinese people closely in order to pick up the correct order for different characters. With lots of practice you can write beautiful Chinese characters too.

Introduction to Pinyin and how to pronounce it

Pinyin is the Chinese phonetic alphabet. It was developed to help children learn to write characters, and foreigners and speakers of other Chinese dialects to pronounce Chinese correctly. It is also very useful for dictionaries, as it provides an alphabetical order by which characters can be organised. However, please be aware that Pinyin is not used much in China, and most Chinese people do not understand Pinyin as they would Chinese characters. In short, Pinyin shouldn't be regarded as a substitute for learning Chinese characters, but it is a good guide to pronunciation.

You will notice accents over some of the letters in Pinyin. These are **tones**. There are four tones: **first tone** (high, even pitch); **second tone** (rising pitch); **third tone** (falling then rising) and **fourth tone** (falling pitch). In addition some sounds are **toneless**. There is no tone mark for a neutral tone.

Tones are a very important part of the pronunciation. Wrong tones can cause real confusion. It may seem odd to native speakers of English to have pitch so rigidly attached to words, but the tone is as fundamental a part of any syllable as its vowels and consonants.

Examples of differences in tones:

First tone	Second tone	Third tone	Fourth tone	Neutral tone
mā	má	mǎ	mà	ma
妈	麻	马	骂	吗
Mother	Hemp	Horse	Curse	[question particle]

Introduction to Pinyin and how to pronounce it

Some of the trickier sounds of Pinyin are listed below:

Pinyin	Sound	(as in) English
c	ts	ca**ts**
chi	chur	**char**
ci	tsur	whi**te surf**
e	er	th**ere's**
ei	ay	m**ay**
ie	yeh	**ye**llow
iu	yo	**yo**yo
o	or	**or**
ou	oh	**oh**
q	ch	**ch**eat
ri	rur	**rur**al, child**ren** (this is not a rolled *r*)
shi	shur	**shir**t
si	sur	ab**surd**
u	oo	s**oo**n
ü	u	like the French "r**ue**", or German "**ü**ber"
ui	way	**way**
uo	war	**war**
x	sh	who'**s she**
z	dz	be**ds**
zh	dj	**j**ar
zhi	jur	in**jur**y
zi	dzur	o**dds ar**e

After most letters such as **j**, **q**, **x** (common sources of confusion), **l**, **n**, **m** and most other consonants:
e is pronounced "eh" (as in "yes")
i is pronounced "eeee" (as in "peaches" or "green")
u is pronounced "oo" like (as in "you"), except after **j**, **q** and **x**, when it is pronounced like the German ü

After the following common consonants or groups of consonants such as **zh**, **ch**, **sh**, **r**, **z**, **c**, **s**:
e is pronounced "ur" (as in "shirt")
i is barely pronounced at all, but the consonant is pronounced in a slightly more long-drawn-out way (think of the r in "grrrrr")
u is pronounced "oo" (as in "you")

Guide to using the book

Topics

The 250 characters in the book are some of the most common characters in use. We have arranged them into thirteen sections, organised by topic. The topics covered are:

- People
- Numbers
- Time
- Location
- Places
- Travelling
- About town
- Shopping
- Restaurants and hotels
- Weather
- Culture
- Colours
- Basics

Getting to know these characters through topics may help you make some thematic associations in the early stages of learning the language. However, you must be careful to distinguish between **characters** and **words**. Most Chinese words are made by combining two or three characters. By themselves, Chinese characters can appear to have quite a narrow, fixed meaning. But when they are combined with other characters, they can take on a much wider meaning, one that is not limited by these topic groups we have created. Realising this, and working out how Chinese makes up words from individual characters, is part of the fun of learning Chinese!

Guide to using the book

Character entries

Every entry shows you the character, the Pinyin sound, and a basic English definition. The information that accompanies each entry is arranged in several bite-sized sections. Look out for the following headings:

1 **Character information** explains how the character was formed. In this book we identify three types of character:

 a Some characters **look like** objects. These characters go right back to the original pictographs used in ancient times. You may think that these are very common, but actually there are not many left in use today.

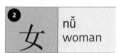

 Character information
 This character looks like a **dancing woman**.

 b Some characters **represent** objects or more abstract ideas by adding basic components together.

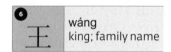

 Character information
 This character represents a **king** as the one (一 yī) who rules over **earth** (土 tǔ).

 c Finally, the most common type of characters are the ones that combine a radical to indicate meaning, with a phonetic to indicate sound.

2 **Examples** shows you how the character is used with other characters to make words. We have chosen common, everyday words that are most use to Chinese learners.

3 **More about radicals** tells you which component in the character is the radical. Usually, when a radical appears in the book for the first time, it will be given an introduction. This introduction explains how the radical may be associated with a

particular meaning, and lists a few examples of other characters that feature the same radical. (We also tell you when a radical is **not** associated with any particular meaning.)

4 **More about phonetics** tells you which component in the character may provide a clue to its sound.

5 **Lost in simplification** points out examples where the components in a traditional form indicate the meaning or sound better than the simplified form. The simplified forms are now preferred in China because they contain fewer strokes and are therefore more convenient to write. However, one of the aims of this book is to tell you about the roots of a character, which is why it is sometimes necessary to take you back to the traditional forms.

6 **Good to know!** gives you some cultural background related to the character or one of the example words. You will also find some additional language information, such as useful phrases you might hear or want to use when you are in China.

7 **Which component comes first?** When you write a character with more than one component, you need to write these components one by one. You usually write left components before right ones, and upper components before lower ones.

8 **Tips on stroke order** gives brief reminders of some of the principles of stroke order that you need to follow in order to write a character correctly. For more detailed information, you should refer back to the earlier **stroke order** section.

9 Be careful! This section highlights any characters that look very similar and which are therefore easily confused.

10 Practise writing the character shows you the stroke order most commonly used by Chinese people. You will also need to refer to the **basic strokes** section to help you work out the direction of the strokes.

11 Cross references If we refer to another character in the book, you will see a cross-reference to the character number in square brackets.

Character number Character Pinyin Translation Traditional character form

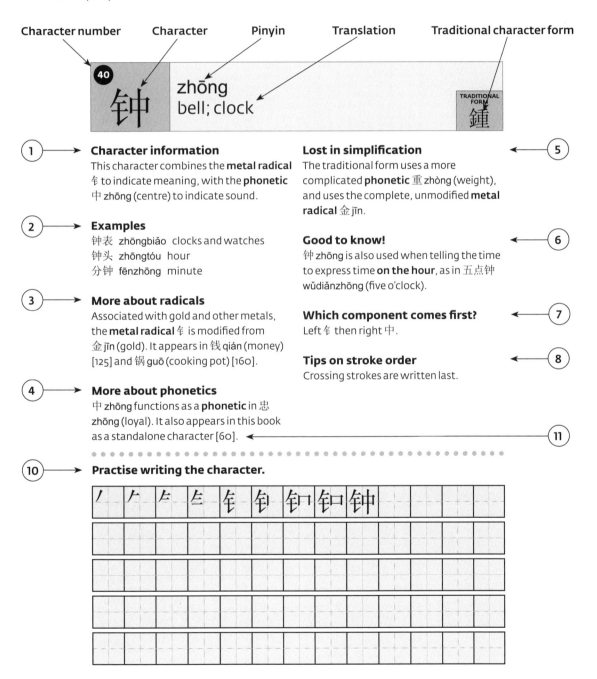

40

钟

zhōng
bell; clock

TRADITIONAL FORM
鍾

1 Character information
This character combines the **metal radical** 钅 to indicate meaning, with the **phonetic** 中 zhōng (centre) to indicate sound.

2 Examples
钟表 zhōngbiǎo clocks and watches
钟头 zhōngtóu hour
分钟 fēnzhōng minute

3 More about radicals
Associated with gold and other metals, the **metal radical** 钅 is modified from 金 jīn (gold). It appears in 钱 qián (money) [125] and 锅 guō (cooking pot) [160].

4 More about phonetics
中 zhōng functions as a **phonetic** in 忠 zhōng (loyal). It also appears in this book as a standalone character [60].

5 Lost in simplification
The traditional form uses a more complicated **phonetic** 重 zhòng (weight), and uses the complete, unmodified **metal radical** 金 jīn.

6 Good to know!
钟 zhōng is also used when telling the time to express time **on the hour**, as in 五点钟 wǔdiǎnzhōng (five o'clock).

7 Which component comes first?
Left 钅 then right 中.

8 Tips on stroke order
Crossing strokes are written last.

10 Practise writing the character.

丿	宀	乇	乍	钅	钅	钅	钅	钟			

Indexes

There are two indexes at the back of the book. There is an alphabetical **Pinyin index**, which lets you find a character according to how it sounds. There is also a **radical index** that groups the characters in the book according to their radicals. The radicals are listed in order of the number of strokes they contain (so, radicals with one stroke are listed before radicals with two strokes, and so on). A few radicals can be written in more than one way (for example, the heart radical has four strokes when it is written in its original form like this 心, but only three strokes when it is written in its modified form like this 忄). In these examples, the stroke count for the original form takes precedent.

People

There are two main types of character in this section: those that relate to people, and those that relate to parts of the body. You will learn how to write the characters for a few common Chinese family names and for some members of your family, such as *mother*, *father*, *brother* and *sister*. You will also find out how to use common pronouns, such as *me* and *you*, and learn how to greet someone and tell them your name.

In the course of this section you will discover that some basic characters can be modified to appear as radical components in other more complex characters. When this happens, the meaning of the new character may be associated with the original basic character (radicals that relate to people and the body are especially reliable for indicating meaning). For example, characters that use the woman radical are usually associated with women in some way (such as *mother* and *sister*), and characters that use the hand radical are usually associated with hand actions in some way (such as *hit*, *push* and *pull*).

You will learn how to write the following characters, and be introduced to the following radicals:

No.	Chinese	Pinyin	English	Radical introductions
1	人	rén	person	The human radical 人 (亻)
2	女	nǚ	woman	The woman radical 女
3	口	kǒu	mouth	The mouth radical 口
4	手	shǒu	hand; expert	The hand radical 手 (扌)
5	心	xīn	heart	The heart radical 心 (忄)
6	王	wáng	king; family name	The king radical 王
7	男	nán	male	The power radical 力
8	你	nǐ	you	
9	他	tā	he	
10	位	wèi	location; measure word	
11	我	wǒ	I; me	The slash radical 丿
12	奶	nǎi	grandmother; milk	
13	妈	mā	mum	
14	妹	mèi	younger sister	
15	姐	jiě	elder sister	
16	婚	hūn	marriage; to marry	
17	名	míng	name	
18	哥	gē	elder brother	
19	爷	yé	grandfather	The father radical 父
20	爸	bà	father	
21	弟	dì	younger brother	
22	张	zhāng	family name; measure word	
23	朋	péng	friend	
24	孩	hái	child	
25	家	jiā	family; home	The roof radical 宀

1

人 rén
person

Character information

This character looks like a **person walking**.

Examples

中国人 Zhōngguórén Chinese person
英国人 Yīngguórén British person
病人 bìngrén (hospital) patient
大人 dàrén adult
人民币 Rénmínbì Renminbi (RMB), the currency of China.

More about radicals

The **human radical** (人 modified to 亻) is associated with **people**. It appears in 你 nǐ (you) [8], 他 tā (he) [9] and 住 zhù (to live) [163].

Good to know!

The currency in China is officially called Renminbi (literally **people's money**). But, when you go shopping in China, people usually say 元 yuán or 块 kuài.

Tips on stroke order

Left falling strokes are written before right falling strokes.

Be careful!

Be careful not to confuse it with 入 rù (to enter) [224].

Practise writing the character.

2

女 nǚ
woman

Character information
This character looks like a **dancing woman**.

Examples
女儿 nǚ'ér daughter
女士 nǚshì lady
女厕所 nǚcèsuǒ ladies' toilet
女朋友 nǚpéngyou girlfriend

More about radicals
The **woman radical** 女 is associated with **women**. It appears in 奶 nǎi (grandmother) [12], 妈 mā (mum) [13] and 妹 mèi (younger sister) [14].

Good to know!
A lot of public toilets in China use the character for woman on signs, so this is a very useful character to remember!

Tips on stroke order
Crossing strokes are written last.

Be careful!
Be careful not to confuse it with 文 wén (culture) [178].

Practise writing the character.

乆	女	女							

3

口 kǒu
mouth

Character information

This character looks like a **mouth**. It is used figuratively in words that relate to **openings** of some kind.

Examples

入口 rùkǒu entrance
出口 chūkǒu exit; export
进口 jìnkǒu import
路口 lùkǒu (road) junction
人口 rénkǒu population

More about radicals

The **mouth radical** 口 is associated with **mouths**, **openings** or **containers**. It appears in 吃 chī (to eat) [128], 喝 hē (to drink) [129] and 唱 chàng (to sing) [200].

Good to know!

The signs for **entrance** and **exit** sometimes omit 口 to save space.

Tips on stroke order

Left vertical strokes are written before top horizontal strokes. Bottom horizontal strokes are written last.

Practise writing the character.

4

手

shǒu
hand; expert

Character information

This character looks like a **hand**.

Examples

手表 shǒubiǎo wristwatch
手机 shǒujī mobile phone
手套 shǒutào gloves
歌手 gēshǒu singer

More about radicals

The **hand radical** 扌 (modified from 手) is associated with **actions**. It appears in 打 dǎ (to hit) [229], 推 tuī (to push) [247], and 拉 lā (to pull) [239].

Tips on stroke order

Horizontal strokes are written before the vertical strokes.

Practise writing the character.

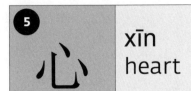

5

心

xīn
heart

Character information
This character looks like a **heart**.

Examples
心情 xīnqíng mood
开心 kāixīn happy
热心 rèxīn warm-hearted
小心 xiǎoxīn to be careful
市中心 shìzhōngxīn city centre

More about radicals
The **heart radical** is associated with **feelings**. It may appear in a modified form 忄 on the left hand side of a character, such as 快 kuài (quick) [157] . Or it may be squeezed into the bottom half of a character, such as 想 xiǎng (to think) [249].

Good to know!
When you see 小心 xiǎoxīn on a sign in a public place, it means there is some kind of minor hazard, perhaps a slippery floor or a concealed step.

Tips on stroke order
Left to right.

Be careful!
Be careful not to confuse it with 火 huǒ (fire) [220].

Practise writing the character.

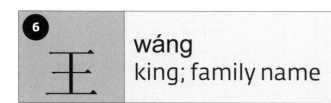

6

王

wáng
king; family name

Character information

This character represents a **king** as the **one** (一 yī) who rules over **earth** (土 tǔ).

Examples

王子 wángzǐ prince
国王 guówáng king
女王 nǚwáng queen
王先生 Wáng xiānsheng Mr. Wang

More about radicals

The **king radical** 王 appears in 球 qiú (ball) [223] and 玉 yù (jade) [183].

Good to know!

Family names come before given names and other forms of address in China. For example, 王菲 Wáng Fēi is a famous Chinese singer and actress. 王小姐 Wáng xiǎojie is Ms. Wang; 王医生 Wáng yīshēng is Dr. Wang; and 王老师 Wáng lǎoshī is Teacher Wang.

Tips on stroke order

Bottom horizontal strokes are written last.

Be careful!

Be careful not to confuse it with 玉 yù (jade) [183].

Practise writing the character.

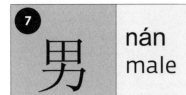

7

男

nán
male

Character information

This character represents a **man** as the **power** (力 lì) in the **field** (田 tián).

Examples

男孩子 nánháizi boy
男朋友 nánpéngyou boyfriend
男人 nánrén man
男厕所 náncèsuǒ men's toilet

More about radicals

The **power radical** 力 lì is associated with **power** or **strength**. It appears in 办 bàn (to handle) or 动 dòng (to move).

Which component comes first?

Upper 田 then lower 力.

Practise writing the character.

丨	冂	冃	甲	田	男	男						

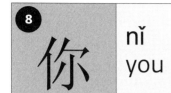

8

你 nǐ
you

Character information
This character combines the **human radical** 亻 to indicate meaning, with 尔 ěr (a classical word for you).

Examples
你们 nǐmen you (plural)
你好 nǐhǎo hello
你好吗？nǐ hǎo ma How are you?

More about radicals
You can read about the **human radical** 亻 by turning back to character [1].

Good to know!
你好 nǐhǎo is the most common way to say **hello** in Chinese.

Which component comes first?
Left 亻 then right 尔.

Tips on stroke order
Centre strokes are written before outside strokes.

Practise writing the character.

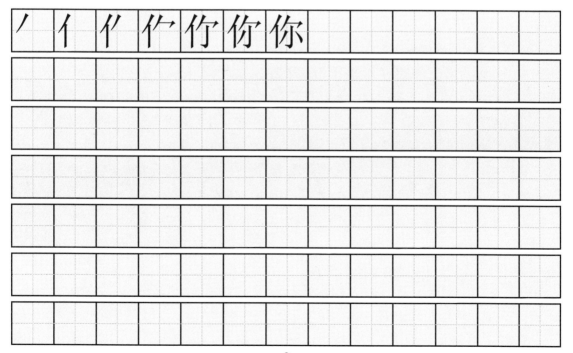

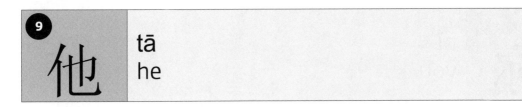

9

他 tā
he

Character information

This character combines the **human radical** 亻 to indicate meaning, with 也 yě (also).

Example

他们 tāmen they

More about radicals

You can read about the **human radical** 亻 by turning back to character [1].

Good to know!

The character for **she** is made by swapping the **person radical** for the **woman radical**, like this 她 tā. Because he and she sound the same in Chinese, misunderstandings can easily arise. This also explains why Chinese learners of English confuse he and she when they speak English.

Which component comes first?

Left 亻 then right 也.

- -

Practise writing the character.

10

wèi
location; measure word

Character information
This character represents a **person** (亻)
standing (立 lì).

Examples
位置 wèizhi location
三位客人 sān wèi kèrén three guests

More about radicals
You can read about the **human radical** 亻
by turning back to character [1].

Good to know!
Chinese uses **measure words** when using
numbers with objects. It works in much

the same way that English may classify
some items like slice of bread or bowl
of soup. However, in Chinese all objects
need a classifier. When you arrive at a
restaurant in China, you will usually be
greeted by a waiter or waitress asking
几位 jǐ wèi, which means **how many
people?** Answer by saying a number
followed by 位 wèi.

Which component comes first?
Left 亻 then right 立.

Tips on stroke order
Bottom horizontal strokes are written
last.

Practise writing the character.

11 我 wǒ I; me

Character information
This character represents a **spear** (戈 gē) in a **hand** (手 shǒu).

Examples
我们 wǒmen us
我的 wǒde my; mine

More about radicals
The **slash radical** 丿 is not associated with the meaning of the character. It appears in 九 jiǔ (nine) [34], 年 nián (year) [51] and 乐 lè (happy) [185].

Tips on stroke order
Minor strokes are written last.

Practise writing the character.

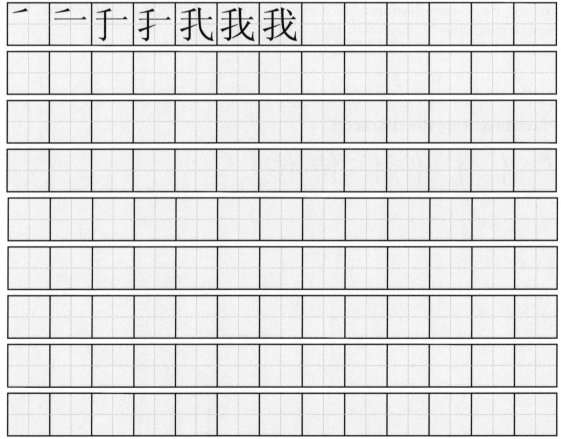

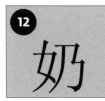

12

奶 nǎi
grandmother; milk

Character information

This character combines the **woman radical** 女 nǚ to indicate meaning, with the **phonetic** 乃 nǎi (a formal word for to be) to indicate the sound.

Examples

奶奶 nǎinai grandmother (father's mother)
奶酪 nǎilào cheese
牛奶 niúnǎi milk
酸奶 suānnǎi yoghurt

More about radicals

You can read about the **woman radical** 女 nǚ by turning back to character [2].

Good to know!

The names for family members change depending on whether they are on your mother's or father's side of the family. Your mother's mother is called 外婆 wàipó, which literally means **old woman on the outside**. This reflects the Chinese view that a wife marries into the husband's family, leaving her parents behind on the 'outside'.

Which component comes first?

Left 女 then right 乃.

Practise writing the character.

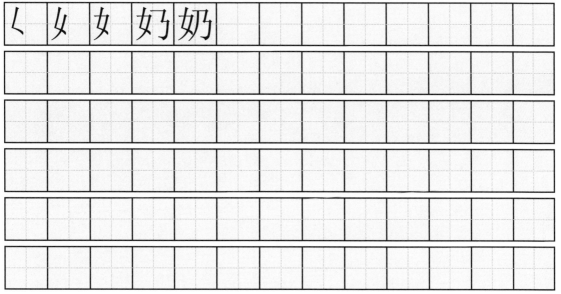

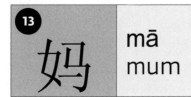

13

妈

mā
mum

Character information
This character combines the **woman radical** 女 nǚ to indicate meaning, with the **phonetic** 马 mǎ (horse) to indicate sound.

Example
妈妈 māma mum

More about radicals
You can read about the **woman radical** 女 nǚ by turning back to character [2].

Which component comes first?
Left 女 then right 马.

Tips on stroke order
Minor strokes are written last.

Practise writing the character.

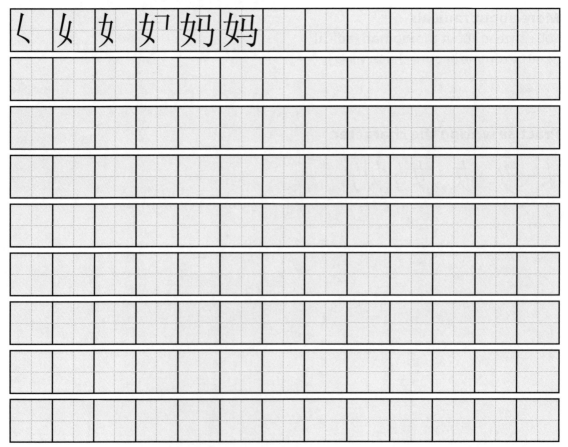

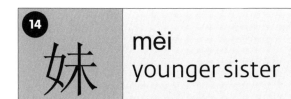

mèi
younger sister

Character information
This character combines the **woman radical** 女 nǔ to indicate meaning, with the **phonetic** 未 wèi (not yet) to indicate sound.

Examples
妹妹 mèimei younger sister
姐妹 jiěmèi sisters
表妹 biǎomèi younger female cousin

More about radicals
You can read about the **woman radical** 女 nǔ by turning back to character [2].

More about phonetics
未 wèi functions as a **phonetic** in 味 wèi (taste; flavour).

Which component comes first?
Left 女 then right 未.

Tips on stroke order
Centre strokes are written before outside strokes.

Practise writing the character.

く	女	女	妇	妒	妊	姝	妹						

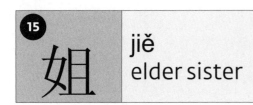

15

姐 jiě
elder sister

Character information

This character combines the **woman radical** 女 nǔ to indicate meaning, with the **phonetic** 且 qiě (moreover) to indicate sound.

Examples

姐姐 jiějie elder sister
表姐 biǎojiě elder female cousin
小姐 xiǎojie miss; a young (unmarried) lady

More about radicals

You can read about the **woman radical** 女 nǔ by turning back to character [2].

Good to know!

小姐 xiǎojie used to be used to address restaurant waitresses. However, more recently the expression has become a euphemism for **prostitute**, and so the original meaning has fallen out of use. Nowadays, people address waiters and waitresses as 服务员 fúwùyuán, literally **service staff**.

Which component comes first?

Left 女 then right 且.

Tips on stroke order

Bottom horizontal stokes are written last.

Practise writing the character.

〈	女	女	女	如	如	如	姐					

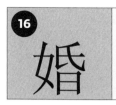

16 婚

hūn
marriage; to marry

Character information
This character combines the **woman radical** 女 nǚ to indicate meaning, with the **phonetic** 昏 hūn (confused) to indicate sound.

Examples
结婚 jiéhūn to marry
婚礼 hūnlǐ wedding ceremony

More about radicals
You can read about the **woman** radical 女 nǚ by turning back to character [2].

Good to know!
It is very uncommon for a couple to live together or have children before marriage. Marriages happen in two stages. Firstly, the couple officially registers their marriage. Days, weeks or even months later, family and friends are invited to a ceremonial banquet in a restaurant. As a wedding gift, it is usual to give the couple money in a red envelope.

Which component comes first?
Left 女 then right (氏 then 日).

Tips on stroke order
Bottom enclosing strokes are written after enclosed strokes.

Practise writing the character.

| 〈 | 女 | 女 | 女ʼ | 妷 | 妷 | 娇 | 娇 | 婚 | 婚 | 婚 | | |

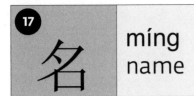

17

名

míng
name

Character information

This character combines the **mouth radical** 口 kǒu to indicate meaning, with 夕 xī (evening).

Examples

名字　míngzi　name
名人　míngrén　famous person
名片　míngpiàn　name card
有名　yǒumíng　famous; well-known

More about radicals

You can read about the **mouth radical** 口 kǒu by turning back to character [3].

Good to know!

You ask **what is your name?** like this: 你叫什么名字　nǐ jiào shénme míngzi? You say **my name is...** like this: 我叫… wǒ jiào …

Which component comes first?

Upper 夕 then lower 口.

Tips on stroke order

Bottom horizontal strokes are written last.

Practise writing the character.

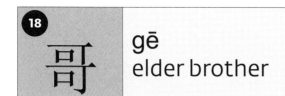

18

哥 gē
elder brother

Character information

This character includes the **phonetic** 可 kě (may) to indicate sound.

Examples

哥哥 gēge elder brother
表哥 biǎogē elder male cousin

More about radicals

You can read about the **one radical** 一 yī by turning forward to character [26].

More about phonetics

哥 gē functions as a **phonetic** in 歌 gē (song) [201].

Good to know!

As with sister, Chinese has different words for elder and younger brother.

Which component comes first?

Upper 可 then lower 可.

Practise writing the character.

people

Character information

This character combines the **father radical** 父 fù to indicate meaning, with 卩 (kneel).

Example

爷爷 yéye grandfather (on your father's side)

More about radicals

The **father radical** 父 fù is associated with **senior males**. It appears in 爸 bà (father) [20].

Lost in simplification

The traditional form contains the **phonetic** 耶 yé (question particle), which has been lost in the simplification process.

Which component comes first?

Upper 父 then lower.

Practise writing the character.

20

爸 bà
father

Character information
This character combines the **father radical** 父 fù to indicate meaning, with the **phonetic** 巴 bā (to hope) to indicate sound.

Example
爸爸 bàba dad

More about radicals
You can read about the **father radical** 父 fù by turning back to character [19].

More about phonetics
巴 bā functions as a **phonetic** in 吧 ba (auxiliary word) [110].

Good to know!
Like other names for close family members, the character is repeated, which Chinese people do to indicate familiarity and closeness. Note how the repeated character is toneless, which means that most of the stress in placed on the first character.

Which component comes first?
Upper 父 then lower 巴.

Practise writing the character.

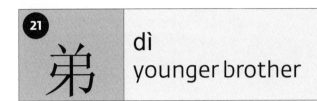

21

弟 dì
younger brother

Character information
This character includes the **divide radical**
八 bā and 弓 gōng (bow).

More about radicals
You can read about the **divide radical**
八 bā by turning forward to character [33].

Examples
弟弟 dìdi younger brother
兄弟 xiōngdì brother (general)
表弟 biǎodì younger male cousin

Practise writing the character.

22

张

zhāng
family name; measure word

TRADITIONAL
FORM

張

Character information

This character combines the **bow radical** 弓 gōng, with the **phonetic** 长 cháng (long) or zhǎng (to grow) to indicate sound.

Examples

张艺谋 Zhāng Yìmóu Zhang Yimou
 (1950-) Chinese film director.
两张票 liǎng zhāng piào two tickets

Good to know!

张 zhāng is one of the "big three" most **common surnames** in China. About 78 million people have this surname, more than the entire population of the UK. 张 zhāng is also a **measure word** used for flat objects such as newspapers, maps, paintings, cards, and tickets, and furniture such as beds, desks and sofas.

Which component comes first?

Left 弓 then right 长.

Practise writing the character.

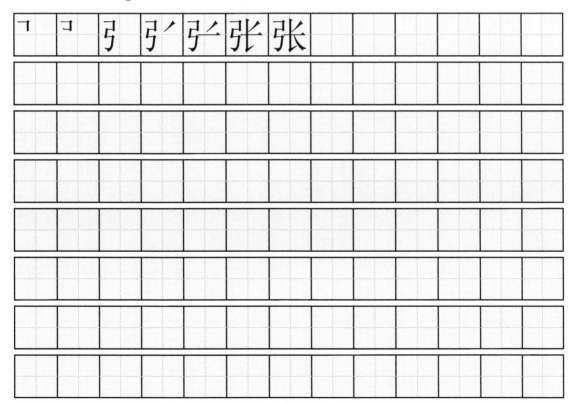

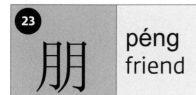

23 朋 péng
friend

Character information

This character includes the **moon radical** 月 yuè.

Examples

朋友　péngyou　friend
男朋友　nánpéngyou　boyfriend
女朋友　nǚpéngyou　girlfriend
好朋友　hǎopéngyou　good friend

More about radicals

You can read about the **moon radical** 月 yuè by turning forward to character [38].

Which component comes first?

Left 月 then right 月.

Tips on stoke order

Enclosing strokes are written before enclosed strokes.

- -

Practise writing the character.

24

hái
child

Character information
This character combines the **child radical** 子 zǐ to indicate meaning, with the **phonetic** 亥 hài (a character used in the traditional Chinese calendar) to indicate sound.

Examples
孩子 háizi child
小孩 xiǎohái child

More about radicals
The **child radical** 子 zǐ also appears in 存 cún (to store) [85].

More about phonetics
亥 hài functions as a **phonetic** in 该 gāi (ought to).

Which component comes first?
Left 子 then right 亥.

Practise writing the character.

25

家

jiā
family; home

Character information

This character combines the **roof radical** 宀 to indicate meaning with 豕 shǐ (pig).

Examples

家具 jiājù furniture
家庭 jiātíng home
家乡 jiāxiāng home town

More about radicals

The **roof radical** 宀 is associated with being **indoors**. It appears in 客 kè (guest) [93], 室 shì (room) [94], and 宫 gōng (palace) [195].

Which component comes first?

Upper 宀 then lower 豕.

· ·

Practise writing the character.

Numbers

The Chinese characters for numbers contain relatively few strokes, and are therefore quite straightforward to learn. Writing the numbers is also a good way of getting used to the stroke order rules, so it is worth spending some time getting them right.

Chinese numbers are not only useful for reading price labels in shops or for finding out how much your meals will cost – they are also used to say the time, the date, days of the week and the months.

In this section, you will learn how to write the following characters, and be introduced to the following radicals:

No.	Chinese	Pinyin	English	Radical introductions
26	一	yī	one	The one radical 一
27	二	èr	two	The two radical 二
28	三	sān	three	
29	四	sì	four	The enclosure radical 囗
30	五	wǔ	five	
31	六	liù	six	The lid radical 亠
32	七	qī	seven	
33	八	bā	eight	The divide radical 八
34	九	jiǔ	nine	
35	十	shí	ten	The cross radical 十
36	两	liǎng	two	

yī
one

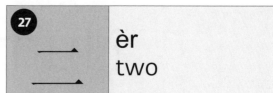

èr
two

Character information

This character represents the idea **one**.

Examples

一些 yīxiē some
一点钟 yīdiǎnzhōng one o'clock
星期一 xīngqīyī Monday
一月 yīyuè January

More about radicals

The **one radical** 一 often has no meaning, but is sometimes associated with **number** or **position**. It appears in 上 shàng (above) [54] to represent the **earth**, and 下 xià (below) [55] to represent the **heavens**.

● ●

Practise writing the character.

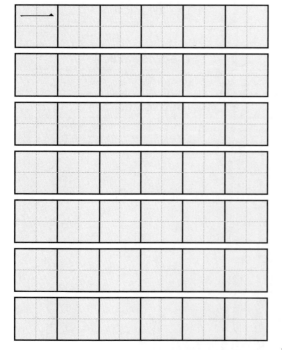

Character information

This character represents the idea **two**.

Examples

星期二 xīngqī'èr Tuesday
二月 èryuè February

More about radicals

The **two radical** 二 appears in 云 yún (cloud) [169] and 元 yuán (a measure word for money) [118].

● ●

Practise writing the character.

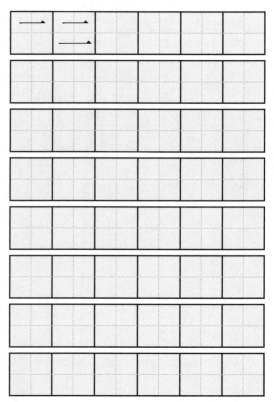

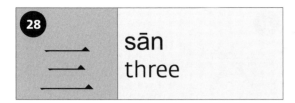

Character information
This character represents the idea **three**.

Examples
三点钟 sāndiǎnzhōng three o'clock
星期三 xīngqīsān Wednesday
三月 sānyuè March

More about radicals
You can read about the **one radical** 一 yī by turning back to character [26].

.

Practise writing the character.

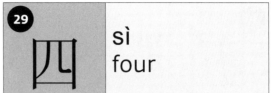

Character information
This character combines the **enclosure radical** 囗 wéi to indicate meaning, with 儿 ér (son).

Examples
四点钟 sìdiǎnzhōng four o'clock
星期四 xīngqīsì Thursday
四月 sìyuè April

More about radicals
The **enclosure radical** 囗 wéi is associated with **boundaries** of some kind. It appears in 国 guó (country) [75]. In the case of 四 sì, it may simply indicate having four sides.

Tips on stroke order
Bottom enclosing strokes are written after enclosed strokes.

. .

Practise writing the character.

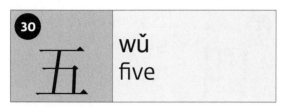

30 五 wǔ five

31 六 liù six

Examples
五点钟 wǔdiǎnzhōng five o'clock
星期五 xīngqīwǔ Friday
五月 wǔyuè May

More about radicals
You can read about the **one radical** 一 yī
by turning back to character [26].

More about phonetics
五 wǔ functions as a **phonetic**, in 语 yǔ
(language) [196].

Tips on stoke order
Bottom horizontal strokes are written last.

· ·

Practise writing the character.

Character information
This character combines the **lid radical** 亠
with 八 bā (eight).

Examples
六点钟 liùdiǎnzhōng six o'clock
星期六 xīngqīliù Saturday
六月 liùyuè June

More about radicals
The **lid radical** 亠 appears in 市 shì (city)
[70], 京 jīng (capital) [71] and 商 shāng
(commerce) [126].

Which component comes first?
Upper 亠 then lower 八.

· ·

Practise writing the character.

32 七 qī seven

33 八 bā eight

Examples

七点钟 qīdiǎnzhōng seven o'clock

七月 qīyuè July

More about radicals

You can read about the **one radical** 一 yī by turning back to character [26].

Tips on stoke order

Horizontal strokes are written before the vertical strokes.

● ●

Practise writing the character.

Character information

This character originally represented **division**.

Examples

八点钟 bādiǎnzhōng eight o'clock

八月 bāyuè August

More about radicals

The **divide radical** 八 appears in other characters, such as 分 fēn (to divide; minute) [41], 公 gōng (public) [107] and 黄 huáng (yellow) [207].

Tips on stoke order

Left falling strokes are written before right falling strokes.

● ●

Practise writing the character.

Examples

九点钟 jiǔdiǎnzhōng nine o'clock
九月 jiǔyuè September

More about radicals

You can read about the **slash radical** 丿
by turning back to character [11].

. .

Practise writing the character.

Examples

十点钟 shídiǎnzhōng ten o'clock
十月 shíyuè October

More about radicals

The **cross radical** 十 indicates the four
points of the compass and is associated
with **completeness**. It appears in 南 nán
(south) [66], 卖 mài (to sell) [121], and 古 gǔ
(ancient) [180].

Good to know!

Now that you know the characters 1-10,
you can make any number up to 99. For
example: 13 is 十三 shísān (literally 'three-
ten'). 20 is 二十 èrshí (literally 'two-ten').
86 is 八十六 bāshíliù (literally 'eight-ten-six').

. .

Practise writing the character.

36

两

liǎng
two

TRADITIONAL
FORM

兩

Character information

This character combines the **one radical** 一 yī with 冂 (open country) and 从 cóng (from).

Good to know!

When citing numbers, 二 èr is used for the **number two**. However, when you want to talk about **two things**, you must use 两 liǎng and a measure word, before the noun. For example, 两个小时 liǎng gè xiǎoshí means **two hours**.

Which component comes first?

Upper 一, lower 冂, and then central 从.

Tips on stroke order

Enclosing strokes are written before enclosed strokes.

Be careful!

Be careful not to confuse it with 内 nèi (inside) [58] or 肉 ròu (meat) [145].

Practise writing the character.

Time

In the previous section you saw how the numbers were used to tell the time. This section builds on that by showing you how to write the other characters needed to say the day, week and month. In addition, this section also helps you to recognize *morning*, *afternoon* and *evening*, which is essential if you want to check the time on a bus or train ticket.

In this section, you will learn how to write the following characters, and be introduced to the following radicals:

No.	Chinese	Pinyin	English	Radical introductions
37	日	rì	sun; day	The sun radical 日
38	月	yuè	moon	The moon radical 月
39	点	diǎn	o'clock; dot; drop	
40	钟	zhōng	bell; clock	The metal radical 钅
41	分	fēn	to divide; minute	
42	半	bàn	half	The dot radical 丶
43	早	zǎo	morning; early	
44	午	wǔ	midday	
45	晚	wǎn	evening	
46	天	tiān	day	
47	时	shí	hour; time	
48	周	zhōu	week; family name	
49	星	xīng	star	
50	期	qī	period of time	
51	年	nián	year	
52	今	jīn	today	
53	明	míng	bright	

time

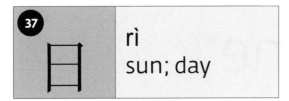

Character information
This character looks like the **sun**.

Examples
日报 rìbào daily newspaper
节日 jiérì traditional holiday
生日 shēngrì birthday
日记 rìjì diary

More about radicals
The **sun radical** 日 is associated with the **sun** and **time**. It appears in 早 **zǎo** (morning) [43], 晚 **wǎn** (evening) [45], and 星 **xīng** (star) [49].

Good to know!
日 rì is used when **writing the date**. So, 14日 means the **14th of the month**.

Tips on stroke order
Bottom enclosing strokes are written after enclosed strokes.

Be careful!
Be careful not to confuse it with 白 bái (white) [204].

. .

Practise writing the character.

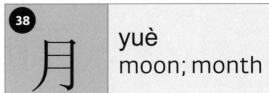

Character information
This character looks like the **crescent-shaped moon**.

Examples
月亮 yuèliang the moon
四月 sìyuè April
月饼 yuèbǐng moon cake

More about radicals
When the **moon radical** 月 appears in other characters on the left side, the meaning is associated with **time**, such as 期 qī (time) [50]. But when it is on the left, the meaning is associated with **the body**, such as 朋 péng (friend) [23].

Tips on stroke order
Enclosing strokes are written before enclosed strokes.

. .

Practise writing the character.

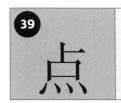

39

diǎn
o'clock; dot; drop

點

Character information
This character combines the **fire radical** 灬 to indicate meaning, with the **phonetic** 占 zhàn (to constitute) to indicate sound.

Examples
早上八点 zǎoshang bādiǎn 8 o'clock in the morning
点菜 diǎncài to order food
一点点 yìdiǎndiǎn a little bit

More about radicals
You can read about the **fire radical** 灬 by turning forward to character [220].

More about phonetics
占 zhàn functions as a **phonetic** in 站 zhàn (to stand) [96] and 店 diàn (shop) [122].

Lost in simplification
The traditional form contains the **black radical** 黑 hēi, to help indicate the meaning **dot**. You can read more about the black radical by turning forward to character [208].

Which component comes first?
Upper 占 then lower 灬.

Practise writing the character.

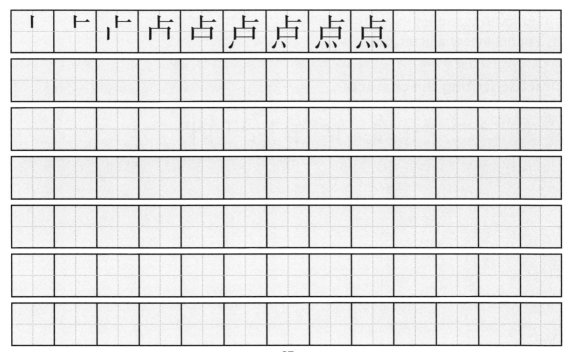

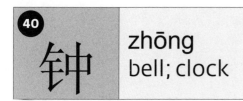

40

钟

zhōng
bell; clock

TRADITIONAL FORM

鍾

Character information
This character combines the **metal radical** 钅 to indicate meaning, with the **phonetic** 中 zhōng (centre) to indicate sound.

Examples
钟表 zhōngbiǎo clocks and watches
钟头 zhōngtóu hour
分钟 fēnzhōng minute

More about radicals
Associated with gold and other metals, the **metal radical** 钅 is modified from 金 jīn (gold). It appears in 钱 qián (money) [125] and 锅 guō (cooking pot) [160].

More about phonetics
中 zhōng functions as a **phonetic** in 忠 zhōng (loyal). It also appears in this book as a standalone character [60].

Lost in simplification
The traditional form uses a more complicated **phonetic** 重 zhòng (weight), and uses the complete, unmodified **metal radical** 金 jīn.

Good to know!
钟 zhōng is also used when telling the time to express time **on the hour**, as in 五点钟 wǔdiǎnzhōng (five o'clock).

Which component comes first?
Left 钅 then right 中.

Tips on stroke order
Crossing strokes are written last.

Practise writing the character.

41 fēn
to divide;
minute

Character information
This character represents **division** (八 bā) by a **knife** (刀 dāo).

Examples
十分钟 shífēnzhōng ten minutes
分开 fēnkāi to separate

More about radicals
You can read about the **divide radical** 八 bā by turning back to character [33].

Good to know!
分 fēn is also used when telling the time to express **minutes past the hour**, as in 五点过五分 wǔdiǎn guò wǔfēn (five minutes past five).

Which component comes first?
Upper 八 then lower 刀.

· ·

Practise writing the character.

42 bàn
half

Character information
This character represents the **division** (八 bā) of a **cow** (牛 niú).

Examples
半价 bànjià half price
半夜 bànyè midnight

More about radicals
The **dot radical** 丶 is not associated with any meaning. It also appears in 学 xué (to study) [192].

Good to know!
半 bàn is also used when telling the time to express **half past the hour**, as in 五点半 wǔdiǎnbàn (half past five).

Tips on stroke order
Crossing strokes are written last.

· ·

Practise writing the character.

time

43

早

zǎo
morning; early

Character information
This character represents the **sun** (日 rì) rising over **all four corners of the world** (十 shí).

Examples
早上 zǎoshang morning
早饭 zǎofàn breakfast
早晚 zǎowǎn sooner or later

More about radicals
You can read about the **sun radical** 日 rì by turning back to character [37].

Good to know!
早 zǎo or 早上好 zǎoshang hǎo are the most common ways of saying **good morning**.

Which component comes first?
Upper 日 then lower 十.

Tips on stroke order
Horizontal strokes are written before the vertical strokes.

● ●

Practise writing the character.

44

午 wǔ
midday

Character information
This character looks like an **ox head**.

Examples
上午 shàngwǔ morning
中午 zhōngwǔ midday
下午 xiàwǔ afternoon
午饭 wǔfàn lunch

More about radicals
You can read about the **slash radical** 丿
by turning back to character [11].

Good to know!
The **Dragon Boat Festival** (端午节
Duānwǔjié) is celebrated on the fifth
day of the fifth month of the Chinese
lunar calendar. The two main activities
which take place at this time are dragon
boat racing and eating 粽子 zòngzi (rice
dumplings).

Tips on stroke order
Horizontal strokes are written before the
vertical strokes.

Practise writing the character.

45

晚 wǎn
evening

Character information
This character combines the **sun radical** 日 rì to indicate meaning, with the **phonetic** 免 miǎn (to evade) to indicate sound.

Examples
晚上 wǎnshang evening
晚饭 wǎnfàn evening meal
晚安 wǎn'ān good night

More about radicals
You can read about the **sun radical** 日 rì by turning back to character [37].

Which component comes first?
Left 日 then right 免.

● ●

Practise writing the character.

| 丨 | 冂 | 日 | 日 | 旷 | 旷 | 旷 | 昀 | 昀 | 映 | 晚 | | |

46 天 tiān
day

Character information

This character represents **heaven** (一 yī) above the **people** (大 dà).

More about radicals

You can read about the **one radical** 一 yī by turning back to character [26].

Examples

昨天 zuótiān yesterday
今天 jīntiān today
明天 míngtiān tomorrow
夏天 xiàtiān summer
冬天 dōngtiān winter

Tips on stroke order

Left falling strokes are written before right falling strokes.

Practise writing the character.

47

时

shí
hour; time

TRADITIONAL FORM

時

Character information

This character combines the **sun radical** 日 rì to indicate meaning, with 寸 cùn (inch).

Examples

时间　shíjiān　time
小时　xiǎoshí　hour
过时　guòshí　outdated

More about radicals

You can read about the **sun radical** 日 rì by turning back to character [37].

Lost in simplification

The traditional form contains a more helpful **phonetic** 寺 sì (temple; mosque). To read more about this phonetic, turn forward to character [189].

Which component comes first?

Left 日 then right 寸.

Tips on stroke order

Minor strokes are written last.

Practise writing the character.

48

周

zhōu
week; family name

Character information

This character combines 土 tǔ (earth) and 口 kǒu (mouth) inside a box 冂.

Examples

周末 zhōumò weekend
上周 shàngzhōu last week
这周 zhèzhōu this week
下周 xiàzhōu next week

More about radicals

You can read about the **slash radical** 丿 by turning back to character [11].

Good to know!

You can say the **days of the week** by saying 周 zhōu followed by a number, up to six for **Saturday**. Add 日 rì to say **Sunday**.

Which component comes first?

Outer 冂 then inner (土 then 口).

Tips on stroke order

Enclosing strokes are written before enclosed strokes.

Practise writing the character.

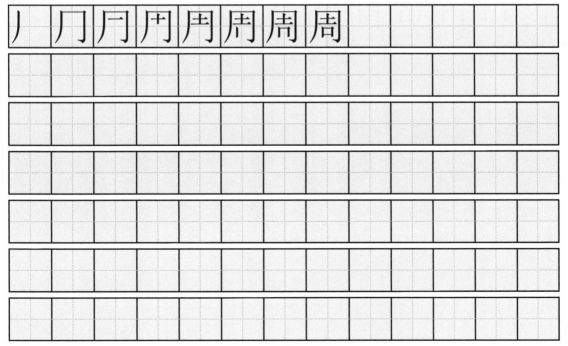

49

星

xīng
star

Character information

This character combines the **sun radical** 日 rì to indicate meaning, with the **phonetic** 生 shēng (life) to indicate sound.

Examples

星期 xīngqī week
明星 míngxīng famous person

More about radicals

You can read about the **sun radical** 日 rì by turning back to character [37].

Good to know!

星期 xīngqī is another word for **week** (see previous character 周 zhōu). You can say the days of the week by saying 星期 xīngqī followed by a number, up to six for **Saturday**. Add 日 rì or 天 tiān to say **Sunday**.

Which component comes first?

Upper 日 then lower 生.

Tips on stroke order

Bottom horizontal strokes are written last.

Practise writing the character.

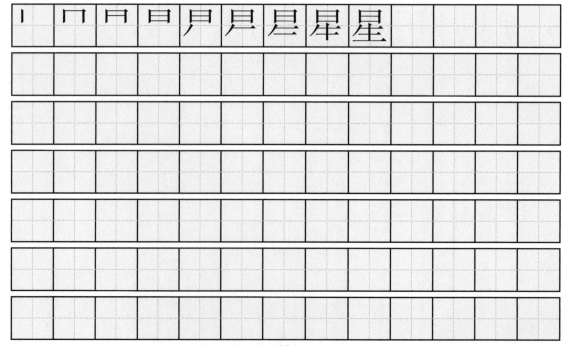

50

期 qī
period of time

Character information
This character combines the **moon radical** 月 yuè to indicate meaning, with the **phonetic** component 其 qí (its) to indicate sound.

Examples
日期 rìqī date
假期 jiàqī holiday
学期 xuéqī school term
星期 xīngqī week

More about radicals
You can read about the **moon radical** 月 yuè by turning back to character [38].

More about phonetics
其 qí functions as a **phonetic** in 欺 qī (to deceive), 棋 qí (chess) and 旗 qí (flag).

Which component comes first?
Left 其 then right 月.

Tips on stroke order
Enclosing strokes are written before enclosed strokes.

Practise writing the character.

| 一 | 十 | 卄 | 卅 | 甘 | 甚 | 其 | 其 | 期 | 期 | 期 | 期 |

51 年 nián year

52 今 jīn today

Character information

This character represents the **annual harvest** by combining **thousands** (千 qiān) of **grains** (禾 hé).

Examples

年龄 niánlíng age
年轻 niánqīng young
新年 xīnnián New Year

More about radicals

You can read about the **slash radical** 丿 by turning back to character [11].

Good to know!

Now that you know the characters for **day**, **month** and **year**, you should be able to check the dates on any bus or train tickets you buy in China. The date is written like this: 2012年6月29日 means **29 June 2012**.

Practise writing the character.

丿	仁	仨	仨	生	年

Character information

This character contains a rare component that means **gathering** (스 jí) of **people**.

Examples

今后 jīnhòu from now on
今年 jīnnián this year
今天 jīntiān today

More about radicals

You can read about the **human radical** 亻 by turning back to character [1].

Tips on stroke order

Top to bottom.

Practise writing the character.

48

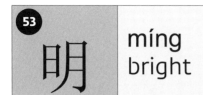

53

明

míng
bright

Character information

This character represents **brightness** by combining the **sun** (日 rì) and **moon** (月 yuè).

Examples

明白 míngbái to understand
明天 míngtiān tomorrow
明信片 míngxìnpiàn postcard
三明治 sānmíngzhì sandwich

More about radicals

You can read about the **sun radical** 日 rì by turning back to character [37].

Which component comes first?

Left 日 then right 月.

Tips on stroke order

Enclosing strokes are written before enclosed strokes.

Practise writing the character.

Location

This section contains some common prepositions and the points of the compass. These will help you describe locations and directions. In the examples, we have also included place names in China which feature some of these common characters.

In this section you will also start to realize how flexible some Chinese characters can be when they are combined with other characters to make new words. Take for instance the character 上 shàng [54]. By itself, it is a preposition meaning *up* or *on*. But when it is combined with other characters it appears in words that mean *last week, to get into a vehicle, to go online,* and *Shanghai*. You would be forgiven for wondering why some of these appear in the location section. The simple answer is that a single character can be used in a wide selection of words, which is reflected in the examples you find on each page throughout the book.

In this section, you will learn how to write the following characters, and be introduced to the following radicals:

No.	Chinese	Pinyin	English	Radical introductions
54	上	shàng	up; on	
55	下	xià	under; off	
56	左	zuǒ	left	The work radical 工
57	右	yòu	right	
58	内	nèi	inside	The line radical 丨
59	外	wài	outside	The divination radical 卜
60	中	zhōng	centre	
61	前	qián	front	The knife radical 刂
62	后	hòu	behind	
63	边	biān	side	
64	北	běi	north	
65	东	dōng	east	
66	南	nán	south	
67	西	xī	west	

location

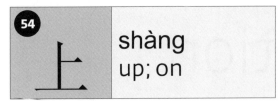

shàng
up; on

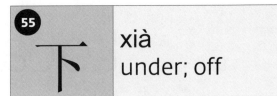

xià
under; off

Character information
This character represents what is **over the ground** (一 yī).

Character information
This character represents what is **under the ground** (一 yī).

Examples
上星期 shàng xīngqī last week
上车 shàngchē to get into a vehicle
上网 shàngwǎng to go online
上海 Shànghǎi Shanghai

Examples
下星期 xià xīngqī next week
下车 xiàchē to get out of a vehicle
下雨 xiàyǔ to rain
下载 xiàzǎi to download

More about radicals
You can read about the **one radical** 一 yī by turning back to character [26].

More about phonetics
下 xià functions as a **phonetic** in 虾 xiā (shrimp) [151].

Tips on stroke order
Bottom horizontal strokes are written last.

Tips on stroke order
Be careful not to confuse it with 不 bù (no) [210].

Practise writing the character.

Practise writing the character.

Character information
This character combines the **work radical** 工 gōng with 𠂇 (hand).

Examples
左边 zuǒbiān the left side
左右 zuǒyòu approximately

More about radicals
The **work radical** 工 gōng looks like a tool, and is sometimes associated with **work**. It appears in 功 gōng (skill) and 项 xiàng (item; project).

Which component comes first?
Upper 𠂇 then lower 工.

Practise writing the character.

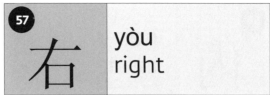

Character information
This character combines the mouth radical 口 kǒu with 𠂇 (hand).

Examples
右边 yòubiān the right side
向右转 xiàng yòu zhuǎn turn right

More about radicals
You can read about the **mouth radical** 口 kǒu by turning back to character [3].

Good to know!
You can ask a taxi driver to **please turn right** by saying 请向右转 qǐng xiàng yòu zhuǎn.

Be careful!
Be careful not to confuse it with the **stone radical** 石 shí.

Practise writing the character.

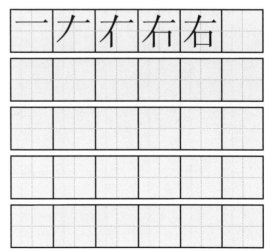

58

内 nèi
inside

TRADITIONAL FORM

内

Character information
This character represents **coming in** (入 rù) from the **open country** (冂).

Examples
内向 nèixiàng introverted
室内 shìnèi indoors
内蒙古 Nèiměnggǔ Inner Mongolia (province)

More about radicals
The **line radical** 丨 is not associated with any meaning. It appears in 中 zhōng (centre) [60], 北 běi (north) [64] and 肉 ròu (meat) [145].

Good to know!
When you are at the airport, you might see the sign 国内 guónèi, which means **domestic flights**.

Which component comes first?
Outer 冂 then inner.

Tips on stroke order
Enclosing strokes are written before enclosed strokes.

Be careful!
Be careful not to confuse it with 两 liǎng (two) [36] or 肉 ròu (meat) [145].

Practise writing the character.

| 丨 | 冂 | 内 | 内 | | | | | | | | |

59

外 wài
outside

Character information
This character combines the **divination radical** 卜 bǔ (mysticism) with 夕 xī (evening).

Examples
外面 wàimiàn outside
外语 wàiyǔ foreign language
外国人 wàiguórén foreigner
外套 wàitào overcoat

More about radicals
The **divination radical** 卜 bǔ is not typically associated with any meaning nowadays.

Good to know!
Notice how the word for **outside** is used in Chinese to refer to **foreign** things.

Which component comes first?
Left 夕 then right 卜.

Be careful!
Be careful not to confuse it with 处 chù (place) [92].

Practise writing the character.

location

60

中 zhōng
centre

Character information

This character represents a **line** (丨) through the middle of an **enclosure** (囗 wéi).

Examples

中国 Zhōngguó China
中文 Zhōngwén Chinese language
中午 zhōngwǔ midday
中秋节 Zhōngqiū Jié Mid-Autumn
　　　Festival

More about radicals

You can read about the **line radical** 丨 by turning back to character [58].

More about phonetics

中 zhōng functions as a **phonetic** in 钟 zhōng (bell; clock) [40].

Good to know!

The **Mid-Autumn Festival** is celebrated on the 15th day of the 8th month of the Chinese lunar calendar. Traditionally families gather together to observe the moon and eat 月饼 yuèbǐng **mooncakes**. The roundness of both the full moon and the cakes symbolizes the unity of the family.

Tips on stroke order

Crossing strokes are written last.

Practise writing the character.

61

前 qián
front

Character information

This character combines the **knife radical** 刂 with 月 yuè (moon) and 丷 (grass).

Examples

前面 qiánmiàn in front
前天 qiántiān the day before yesterday
前年 qiánnián the year before last
以前 yǐqián before

More about radicals

Sometimes associated with **cutting**, the **knife radical** 刂 is modified from 刀 dāo (knife). It appears in 剧 jù (drama; play) [197].

More about phonetics

刂 functions as a **phonetic** in 到 dào (to arrive) [89].

Which component comes first?

Upper 丷 then lower (月 then 刂).

• •

Practise writing the character.

丶	丷	丷	丬	肀	肖	前	前				

62 后 hòu behind TRADITIONAL FORM 後

Character information
This character combines 厂 chǎng (factory) with 一 yī (one) and 口 kǒu (mouth).

Examples
后面 hòumiàn back
后天 hòutiān the day after tomorrow
后年 hòunián the year after next
以后 yǐhòu after

More about radicals
You can read about the **slash radical** 丿 by turning back to character [11].

Lost in simplification
The components of the traditional form combine to mean somebody who has difficulty walking and cannot keep up.

63 边 biān side TRADITIONAL FORM 邊

Character information
This character combines the **walk radical** 辶 with 力 lì (power).

Examples
北边 běibiān north
路边 lùbiān roadside
海边 hǎibiān coast
旁边 pángbiān side

Which component comes first?
Inner 力 then outer 辶.

Tips on stroke order
Bottom enclosing strokes are written after enclosed strokes.

Practise writing the character.

Practise writing the character.

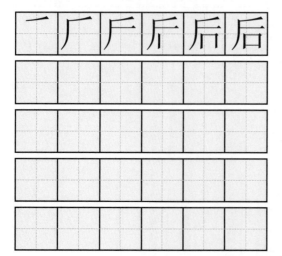

64 北 běi north

Examples
北京 Běijīng Beijing (capital of China)
北美 Běiměi North America
西北 xīběi northwest
东北 dōngběi northeast

More about radicals
You can read about the **line radical** | by turning back to character [58].

Good to know!
Beijing, the capital of China, literally means **northern capital**.

Which component comes first?
Left then right 匕.

Be careful!
Be careful not to confuse the right-hand component 匕 with 七 qī (seven) [32].

65 东 dōng east · TRADITIONAL FORM 東

Examples
东京 Dōngjīng Tokyo
东方 dōngfāng the Orient
广东 Guǎngdōng Guangdong Province
东西 dōngxi thing

Lost in simplification
The components of the traditional form combine to represent the **sun** (日 rì) rising behind a **tree** (木 mù).

Tips on stroke order
Centre strokes are written before outside strokes.

Be careful!
Be careful not to confuse it with 车 chē (vehicle) [91].

Practise writing the character.

Practise writing the character.

66

南 nán
south

Character information

This character includes the **ten radical** 十 shí to indicate meaning, and 冂 (open country).

Examples

南京 **Nánjīng** Nanjing (capital of Jiangsu Province)
南美 **Nánměi** South America
西南 **xīnán** southwest
云南 **Yúnnán** Yunnan Province

More about radicals

You can read about the **cross radical** 十 shí by turning back to character [35].

Which component comes first?

Upper 十 then lower.

Tips on stroke order

Enclosing strokes are written before enclosed strokes.

Practise writing the character.

67

西 xī
west

Character information

This character looks like a **bird roosting in its nest**.

Examples

西藏 Xīzàng Tibet
西班牙 Xībānyá Spain
西餐 xīcān Western food
西红柿 xīhóngshì tomato

Which component comes first?

Upper 一, lower 口 then central 儿.

Tips on stroke order

Enclosing strokes are written before enclosed strokes. Bottom horizontal strokes are written last.

Be careful!

Be careful not to confuse it with 四 sì (four) [29].

● ●

Practise writing the character.

Places

In this section, we have selected several characters related to natural geography, such as *river*, *mountain* and *forest*. As well as being used in the names of famous geographical landmarks in China, these kinds of characters often appear in the names of cities and provinces.

The earth and wood radicals, introduced here, are especially helpful at indicating part of the meaning of characters that feature them.

In this section, you will learn how to write the following characters, and be introduced to the following radicals:

No.	Chinese	Pinyin	English	Radical introductions
68	地	dì	land	The earth radical 土
69	城	chéng	town; city	
70	市	shì	city; market	
71	京	jīng	capital	
72	都	dū; dōu	city; all	The town radical 阝 (right)
73	省	shěng	province; to save	
74	州	zhōu	state	
75	国	guó	country	
76	山	shān	mountain	The mountain radical 山
77	林	lín	wood; forest; family name	The wood radical 木
78	江	jiāng	river	
79	河	hé	river	
80	湖	hú	lake	
81	港	gǎng	harbour	
82	海	hǎi	sea	

68

dì
land

Character information

This character combines the **earth radical** 土 tǔ to indicate meaning, with the **phonetic** 也 yě (also) to indicate sound.

Examples

地方 dìfāng place
地铁 dìtiě underground (subway)
地图 dìtú map
地址 dìzhǐ address

More about radicals

The **earth radical** 土 tǔ is associated with the **earth** or the **ground**. It appears in 城 chéng (city; town) [69], 坐 zuò (to sit; to travel by) [86], and 寺 sì (temple) [189].

Which component comes first?

Left 土 then right 也.

Be careful!

Be careful not to confuse it with 他 tā (he) [9].

. .

Practise writing the character.

69

城

chéng
town; city

Character information

This character combines the **earth radical** 土 tǔ to indicate meaning, with the **phonetic** 成 chéng (to accomplish) to indicate sound.

Examples

城市　chéngshì　town; city
长城　Chángchéng　The Great Wall

More about radicals

You can read about the **earth radical** 土 tǔ by turning back to character [68].

More about phonetics

成 chéng functions as a **phonetic** in 诚 chéng (sincere; honest).

Which component comes first?

Left 土 then right 成.

Tips on stroke order

Minor strokes are written last.

Be careful!

Be careful not to confuse it with 咸 xián (salted) [153].

Practise writing the character.

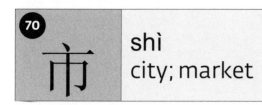

70

市

shì
city; market

Character information
This character combines the **lid radical** ⼇ with 巾 jīn (towel).

Examples
市场 shìchǎng market
超市 chāoshì supermarket
市中心 shìzhōngxīn city centre

More about radicals
You can read about the **lid radical** ⼇ by turning back to character [31].

Good to know!
It is common to see the character used with city names on timetables and train or bus tickets, as in 北京市 Běijīngshì (Beijing).

Which component comes first?
Upper ⼇ then lower 巾.

Tips on stroke order
Crossing strokes are written last.

Practise writing the character.

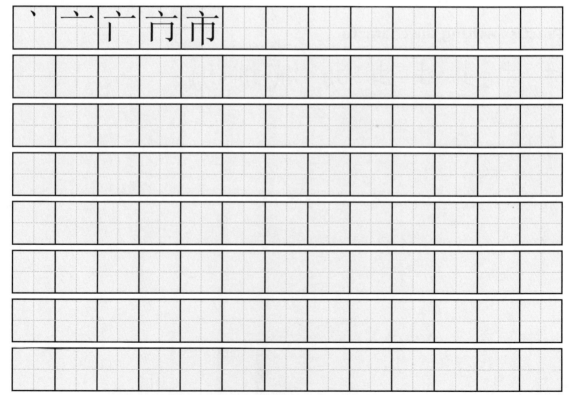

71

京 jīng
capital

Character information

This character combines the **lid radical** ⼇ with 口 kǒu (mouth) and 小 xiǎo (small).

Examples

京剧 jīngjù Beijing opera

北京 Běijīng Beijing (capital of China)

南京 Nánjīng Nanjing (capital of Jiangsu Province)

More about radicals

You can read about the **lid radical** ⼇ by turning back to character [31].

More about phonetics

京 jīng functions as a **phonetic** in 凉 liáng (cool) [156] and 影 yǐng (film) [203].

Which component comes first?

Upper ⼇, central 口 then lower 小.

Tips on stroke order

Centre strokes are written before outside strokes.

Be careful!

Be careful not to confuse it with 凉 liáng (cool) [156].

Practise writing the character.

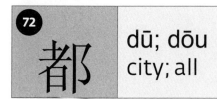

72

都 dū; dōu
city; all

Character information

This character combines the **town radical** 阝 to indicate meaning, with 者 zhě (person).

Examples

首都 shǒudū capital
成都 Chéngdū Chengdu (capital of Sichuan Province).

More about radicals

The **town radical** 阝 (modified from 邑 yì) is associated with **towns**. It appears on the right side of characters.

Good to know!

The full name of the airport in Beijing is 北京首都国际机场 Běijīng Shǒudū Guójì Jīchǎng (Beijing Capital International Airport).

When 都 means **city** it is pronounced dū. But when it means **all** it is pronounced dōu.

Which component comes first?

Left 者 then right 阝.

Practise writing the character.

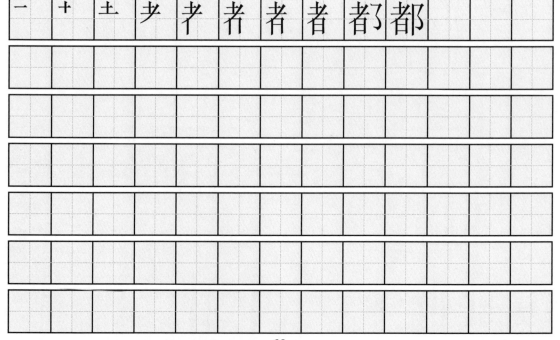

73 省

shěng
province; to save

Character information
This character combines 少 shǎo (few) with 目 mù (eye).

Examples
省钱 shěngqián to save money
甘肃省 Gānsùshěng Gansu Province

More about radicals
You can read about the **small radical** 小 xiǎo by turning forward to character [214].

Which component comes first?
Upper 少 then lower 目.

Tips on stroke order
Centre strokes are written before outside strokes.

Be careful!
Be careful not to confuse the component 目 mù (eye) with 日 rì (day) [37].

• •

Practise writing the character.

74

州

zhōu
state

Character information

This character looks like **rivers** (川 chuān) flowing through the **land**.

Examples

广州 **Guǎngzhōu** Guangzhou (capital of Guangdong Province)

加州 **Jiāzhōu** State of California

More about radicals

You can read about the **slash radical** ノ by turning back to character [11].

Tips on stroke order

Left to right.

- -

Practise writing the character.

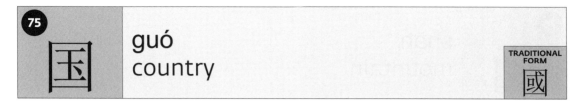

75

国

guó
country

TRADITIONAL
FORM

國

Character information

This character represents **jade** (玉 yù) within **borders** (囗 wéi).

Examples

国家 guójiā country
国庆节 Guóqīng Jié National Day
英国 Yīngguó United Kingdom
美国 Měiguó United States of America
中国 Zhōngguó China

Lost in simplification

The traditional form represents an **estate** 或 (huò) within **borders** (囗 wéi). The inner component has the additional benefit of being a **phonetic** to indicate sound. In the simplification process the **phonetic**

is lost, but the replacement component jade (玉 yù) cleverly retains the spirit of the traditional character.

Good to know!

国庆节 Guóqìng Jié **National Day** falls on 1 October and commemorates the anniversary of the founding of the People's Republic of China in 1949.

Which component comes first?

Outer 囗 then inner 玉.

Tips on stroke order

First outside, then inside, then 'close the door'.

- -

Practise writing the character.

76

山 shān
mountain

Character information
This character looks like a **mountain**.

Examples
山东 **Shāndōng** Shandong Province
山西 **Shānxī** Shanxi Province
华山 **Huà Shān** Mount Hua (in Shaanxi
 Province)
黄山 **Huáng Shān** Yellow Mountain
 (in Anhui Province)

More about radicals
The **mountain radical** 山 shān is associated with **mountains**. It appears in 岭 lǐng (ridge) and 岩 yán (cliff).

• •

Practise writing the character.

丨	山	山									

places

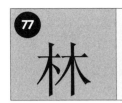

77

林

lín
wood; forest; family name

Character information
This character represents the idea of **forest**, by combining two **wood radicals** (木 mù).

Examples
森林 sēnlín forest
穆斯林 Mùsīlín Muslim
桂林 Guìlín Guilin (city in Guangxi Province)

More about radicals
The **wood radical** 木 mù is associated with **wood** or **trees**. It appears in 机 jī (machine) [104], 梨 lí (pear) [152], and 杯 bēi (cup) [159].

More about phonetics
林 lín functions as a **phonetic** in 禁 jìn (to prohibit) [250].

Which component comes first?
Left 木 then right 木.

Tips on stroke order
Horizontal strokes are written before the vertical strokes. Centre strokes are written before outside strokes.

Practise writing the character.

一 十 才 木 木 村 材 林

78

jiāng
river

Character information

This character combines the **water radical** 氵 to indicate meaning, with the **phonetic** 工 gōng (work) to indicate sound.

Examples

江西 Jiāngxī Jiangxi Province
长江 Cháng Jiāng Yangtze River
浙江 Zhèjiāng Zhejiang Province

More about radicals

You can read about the **water radical** 氵 by turning forward to character [130].

More about phonetics

工 gōng functions as a **phonetic** in 红 hóng (red) [205], 功 gōng (skill), and 空 kōng (empty).

Good to know!

The Yangtze is the longest river in China, which explains its Chinese name (literally, **long river**!).

Which component comes first?

Left 氵 then right 工.

Tips on stroke order

Bottom horizontal strokes are written last.

Be careful!

Be careful not to confuse it with 红 hóng (red) [205].

Practise writing the character.

79

河

hé
river

Character information

This character combines the **water radical** 氵 to indicate meaning, with the **phonetic** 可 kě (can) to indicate sound.

Examples

河岸　hé'àn　river bank
黄河　Huáng Hé　Yellow River

More about radicals

You can read about the **water radical** 氵 by turning forward to character [130].

Good to know!

The Yellow River is the second-longest river in China.

Which component comes first?

Left 氵 then right 可.

· ·

Practise writing the character.

80

湖

hú
lake

Character information

This character combines the **water radical** 氵 to indicate meaning, with the **phonetic** 胡 hú (beard) to indicate sound.

Examples

湖北　**Húběi**　Hubei Province
湖南　**Húnán**　Hunan Province
西湖　**Xīhú**　West Lake (in the city of Hangzhou)

More about radicals

You can read about the **water radical** 氵 by turning forward to character [130].

Which component comes first?

Left 氵, central 古 then right 月.

Tips on stroke order

Enclosing strokes are written before enclosed strokes.

● ●

Practise writing the character.

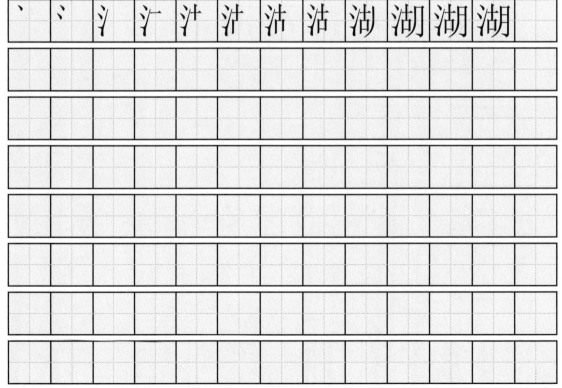

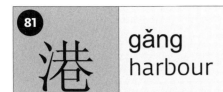

81
港 găng
harbour

Character information
This character combines the **water radical** 氵 to indicate meaning, with 共 gòng (altogether) and 巳 sì (a character used in the traditional Chinese calendar).

Examples
港口 găngkǒu port
香港 Xiānggǎng Hong Kong

More about radicals
You can read about the **water radical** 氵 by turning forward to character [130].

Good to know!
In China, 台港澳 Tái Găng Ào refers to **Taiwan**, **Hong Kong** and **Macao**.

Which component comes first?
Left 氵 then right (共 then 巳).

Practise writing the character.

82 海 hǎi — sea

Character information

This character combines the **water radical** 氵 to indicate meaning, with the **phonetic** 每 mĕi (each; every) to indicate sound. The character also represents the idea that each drop of water ends in the sea.

More about radicals

You can read about the **water radical** 氵 by turning forward to character [130].

Which component comes first?

Left 氵 then right 每.

Examples

海滩 hǎitān beach
海鲜 hǎixiān seafood
上海 Shànghǎi Shanghai

Practise writing the character.

Travelling

This section includes characters that can be used in words that relate to travelling by bus, train, and plane. Some characters might seem like a strange fit for the topic, but usually the examples will make things clearer. For instance, 照zhào [97] means bright, but appears in travel-related words, such as photograph, passport and camera. Likewise, the adjectives *hard* and *soft* appear here because they can be used to refer to different classes of carriage on Chinese trains.

In this section, you will learn how to write the following characters, and be introduced to the following radicals:

No.	Chinese	Pinyin	English	Radical introductions
83	去	qù	to go	The private radical 厶
84	行	xíng	to walk; to travel	The step radical 彳
85	存	cún	to exist	The child radical 子
86	坐	zuò	to sit; to travel by	
87	来	lái	to come	
88	走	zǒu	to walk; to leave	The run radical 走
89	到	dào	to arrive; to go	
90	旅	lǚ	to travel	The square radical 方
91	车	chē	vehicle	The cart radical 车
92	处	chù	place	
93	客	kè	visitor	
94	室	shì	room	
95	票	piào	ticket	The sign radical 示
96	站	zhàn	to stand	The stand radical 立
97	照	zhào	to light up	
98	租	zū	to hire	
99	硬	yìng	hard	The stone radical 石
100	软	ruǎn	soft	
101	铁	tiě	iron (metal)	
102	铺	pù	plank bed; berth	
103	飞	fēi	to fly (airplane)	The second radical 乙(乁 / 乛 / 乚)
104	机	jī	machine	
105	际	jì	border	The mound radical 阝 (left)
106	登	dēng	to go up	

83 去 qù to go

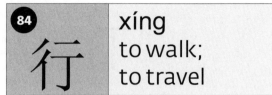

84 行 xíng to walk; to travel

Character information
This character combines the **private radical** 厶 sī with 土 tǔ (earth).

Examples
去年 qùnián last year
去世 qùshì to pass away

More about radicals
The **private radical** 厶 sī appears in other characters such as 能 néng (to be able) [245].

Which component comes first?
Upper 土 then lower 厶.

. .

Practise writing the character.

Character information
This character combines the **step radical** 彳 to indicate meaning, with 亍 chù (to step).

Examples
行李 xíngli luggage
旅行 lǚxíng to travel
步行街 bùxíngjiē pedestrianised street

More about radicals
The **step radical** 彳 is associated with **roads** and **walking**. It appears in 街 jiē (street) [116].

Which component comes first?
Left 彳 then right 亍.

Be careful!
Be careful not to confuse it with 街 jiē (street) [116].

. .

Practise writing the character.

85

cún
to exist

Character information

This character combines the **child radical** 子 zǐ to indicate meaning, with an altered version of the **phonetic** 才 cái (talent) to indicate sound.

Examples

存款 cúnkuǎn savings
存在 cúnzài to exist

More about radicals

The **child radical** 子 zǐ is associated with **children**. It appears in 孩 hái (child) [24].

Good to know!

If you need to store anything in **left luggage** at the train or bus station, look for the sign 行李寄存 xíngli jìcún.

Which component comes first?

Outer then inner 子.

Tips on stroke order

Crossing strokes are written last.

Practise writing the character.

86

坐

zuò
to sit; to travel by

Character information

This character represents **people** (人 rén) seated on the **ground** (土 tǔ).

Examples

坐下 zuòxia sit down
坐飞机 zuò fēijī to travel by plane

More about radicals

You can read about the **earth radical** 土 tǔ by turning back to character [68].

Which component comes first?

Upper (人 then 人) then lower 土.

Tips on stroke order

Bottom horizontal strokes are written last.

• •

Practise writing the character.

87

来

lái
to come

TRADITIONAL
FORM

來

Character information

The traditional form looks like **ears of wheat** (从 cóng) hanging from a **wheat plant** (木 mù).

Be careful!

Be careful not to confuse it with 米 mǐ (rice) [144].

Examples

来回 láihuí to make a round trip
来自 láizì to come from
近来 jìnlái lately

Practise writing the character.

88

走

zǒu
to walk; to leave

Character information
This character represents **feet** (止 zhǐ) and **ground** (土 tǔ).

Examples
走路　zǒulù　to walk
走廊　zǒuláng　corridor
慢走　mànzǒu　mind how you go

More about radicals
The **run radical** 走 zǒu is associated with **speed**. It appears in 超 chāo (to exceed) [127].

Good to know!
When you get out of a taxi or leave a restaurant, you may hear the phrase 慢走 mànzǒu (literally, **slowly go**), which is a polite way to say goodbye.

Which component comes first?
Upper 土 then lower 止 (but notice that this component has undergone alteration as the character has developed over time).

Tips on stroke order
Bottom enclosing strokes are written after enclosed strokes.

Practise writing the character.

89

到 dào
to arrive; to go

Character information

This character combines 至 zhì (until) to indicate meaning, with the **knife radical-phonetic** 刂 dāo to indicate sound.

Examples

到达 dàodá to arrive
到底 dàodǐ at last
迟到 chídào to be late

More about radicals

You can read about the **knife radical** 刂 by turning back to character [61].

Which component comes first?

Left 至 then right 刂.

● ●

Practise writing the character.

90

旅 lǚ
to travel

Character information

This character includes the **square radical** 方 fāng.

Examples

旅馆 lǚguǎn hotel
旅客 lǚkè passenger
去旅游 qù lǚyóu to go on holiday

More about radicals

The **square radical** 方 fāng is associated with **squareness**. It appears in 房 fáng (house; room) [165].

Which component comes first?

Left 方 then right.

Practise writing the character.

丶	亠	广	方	方	方	方	旅	旅	旅			

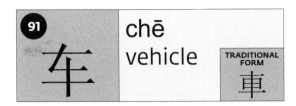

Character information

The traditional form looks like a **chariot** or **cart**.

Examples

车站 chēzhàn railway station; bus stop
公共汽车 gōnggòng qìchē bus
火车 huǒchē train
汽车 qìchē car

More about radicals

The **cart radical** 车 chē is associated with **vehicles**. It appears in 软 ruǎn (soft) [100] and 轮 lún (wheel).

Be careful!

Be careful not to confuse it with 东 dōng (east) [65].

Practise writing the character.

Character information

This character combines the **go radical** 夂 zhǐ with 卜 bǔ (divination).

Examples

到处 dàochù everywhere
售票处 shòupiàochù ticket office
报到处 bàodàochù registration
 (e.g. at a conference)

Which component comes first?

Left 夂 then right 卜.

Practise writing the character.

93

客

kè
visitor

Character information
This character combines the **roof radical** 宀 to indicate meaning, with the **phonetic** 各 gè (each) to indicate sound.

Examples
客厅 kètīng living room
客户 kèhù customer
客气 kèqi polite
旅客 lǚkè passenger

More about radicals
You can read about the **roof radical** 宀 by turning back to character [25].

Which component comes first?
Upper 宀 then lower (夂 then 口).

Tips on stroke order
Bottom horizontal strokes are written last.

Practise writing the character.

94

shì
room

Character information

This character combines the **roof radical** 宀 to indicate meaning, with the **phonetic** 至 zhì (until) to indicate sound.

Examples

教室 jiàoshì classroom
办公室 bàngōngshì office
浴室 yùshì bathroom

More about radicals

You can read about the **roof radical** 宀 by turning back to character [25].

Which component comes first?

Upper 宀 then lower 至.

Tips on stroke order

Bottom horizontal strokes are written last.

Practise writing the character.

95
piào
ticket

Character information
This character combines the **sign radical** 示 shì to indicate meaning, with 覀 (west, a modification of 西 xī).

Examples
车票 chēpiào bus ticket
发票 fāpiào receipt
买票 mǎipiào to buy a ticket
邮票 yóupiào postage stamp

More about radicals
The **sign radical** 示 shì is associated with **showing**. It appears in 禁 jìn (to prohibit) [250].

Good to know!
The measure word for ticket is 张 zhāng. So, if you are buying **three tickets**, you should say 三张票 sān zhāng piào.

Which component comes first?
Upper 覀 then lower 示.

Tips on stroke order
Centre strokes are written before outside strokes.

Practise writing the character.

一	一	一	西	西	西	西	票	票	票		

96

站

zhàn
to stand

Character information

This character combines the **stand radical** 立 lì to indicate meaning, with the **phonetic** 占 zhàn (to constitute) to indicate sound.

Examples

站台　zhàntái　(railway) platform
火车站　huǒchēzhàn　railway station
公共汽车站　gōnggòng qìchēzhàn　bus stop
加油站　jiāyóuzhàn　petrol station
网站　wǎngzhàn　website

More about radicals

The **stand radical** 立 lì looks like **a person standing up**. It appears as a component of 位 wèi (location) [10].

More about phonetics

占 zhàn functions as a **phonetic** in 点 diǎn (o'clock) [39] and 店 diàn (shop) [122].

Which component comes first?

Left 立 then right 占.

Tips on stroke order

Bottom horizontal strokes are written last.

Be careful!

Be careful not to confuse it with 店 diàn (shop) [122].

Practise writing the character.

丶	亠	亠	立	立	立	立	站	站	站				

97

照

zhào
to light up

Character information
This character represents **clarity** (昭 zhāo) by the light of a **fire** (灬),

Examples
照片 zhàopiàn photograph
照相机 zhàoxiàngjī camera
护照 hùzhào passport

More about radicals
You can read about the **fire radical** 灬 by turning forward to character [220].

More about phonetics
召 zhào (to convene) functions as a **phonetic** in 超 chāo (to exceed; super) [127] and 招 zhāo (to beckon).

Which component comes first?
Upper (日, 刀 then 口) then lower 灬

• •

Practise writing the character.

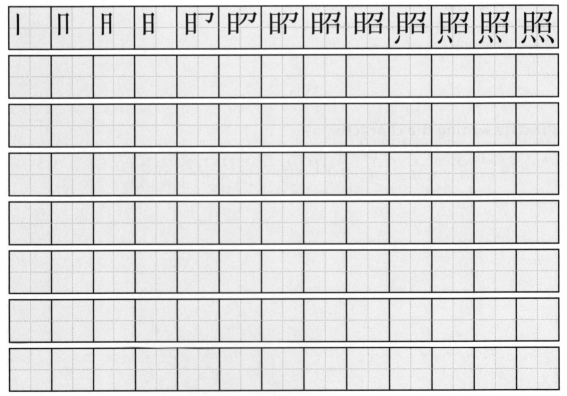

98

zū
to hire

Character information

This character represents **grain** (禾 hé) on an **offering table** (且 qiě).

Example

出租车 chūzūchē taxi

Which component comes first?

Left 禾 then right 且.

Be careful!

Be careful not to confuse it with 姐 jiě (elder sister) [15].

Practise writing the character.

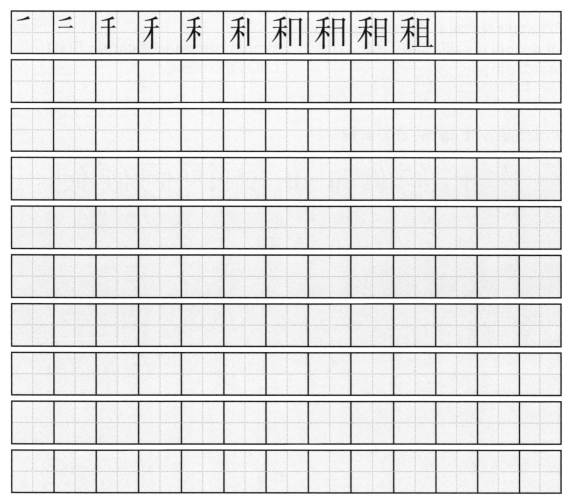

一 二 千 禾 禾 利 和 租 租 租

99 硬 yìng hard

Character information

This character combines the **stone radical** 石 shí to indicate meaning, with the **phonetic** 更 gèng (more) to indicate sound.

Examples

硬币 yìngbì coin
硬座 yìngzuò hard seat (train class)
硬卧 yìngwò hard sleeper (train class)

More about radicals

The **stone radical** 石 shí represents **a rock at the foot of a cliff**. It also appears in 碗 wǎn (bowl) [161].

Good to know!

Train travel in the 'hard seat' carriage is one of the cheapest ways to get around. Some people would say a trip to China is not complete without experiencing a crowded and noisy hard seat journey. However, for overnight journeys you might be more comfortable in a 'hard sleeper' carriage, which offers top (上铺 shàngpù), middle (中铺 zhōngpù), or lower (下铺 xiàpù) berths.

Which component comes first?

Left 石 then right 更.

Practise writing the character.

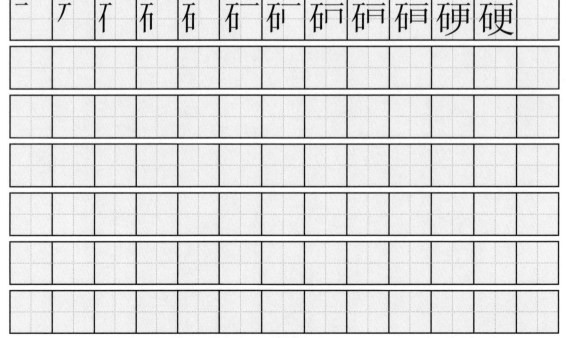

100 软 ruǎn soft

TRADITIONAL FORM
軟

Character information

This character combines the **cart radical** 车 chē to indicate meaning, with the **phonetic** 欠 qiàn (to lack) to indicate sound.

Examples

软件 ruǎnjiàn software
软卧 ruǎnwò soft sleeper (train class)

More about radicals

You can read about the **cart radical** 车 chē by turning back to character [91].

Lost in simplification

Notice how the traditional form uses the traditional **vehicle radical** 車 chē.

Good to know!

Train travel in the 'soft sleeper' carriage is more luxurious (and more expensive) than 'hard sleeper', as there are private compartments with only four berths: two top (上铺 shàngpù) and two lower (下铺 xiàpù).

Which component comes first?

Left 车 then right 欠.

Tips on stroke order

Left falling strokes are written before right falling strokes.

Practise writing the character.

一	七	车	车	轫	轫	轫	软					

101

铁 tiě
iron (metal)

鐵

Character information

This character combines the **metal radical** 钅 to indicate meaning, with 失 shī (lose).

Examples

铁路 tiělù railway
地铁 dìtiě underground (subway)

More about radicals

You can read about the **metal radical** 钅 by turning back to character [40].

Lost in simplification

The traditional form contains the **phonetic** 戴 tiè (large), which has been lost in the simplification process.

Good to know!

铁路 tiělù literally means **iron road**.

Which component comes first?

Left 钅 then right 失.

Tips on stroke order

Left falling strokes are written before right falling strokes.

Practise writing the character.

ノ	ﾉ	ﾉ	ﾉ	钅	钅	钅	钅	铁	铁			

102 铺 pù
plank bed; berth

鋪

Character information

This character combines the **metal radical** 钅 to indicate meaning, with the **phonetic** 甫 fǔ (just) to indicate sound.

Examples

卧铺　wòpù　sleeper (bus; train)
上铺　shàngpù　upper berth
中铺　zhōngpù　middle berth
下铺　xiàpù　lower berth

More about radicals

You can read about the **metal radical** 钅 by turning back to character [40].

Lost in simplification

Notice how the traditional form uses the unmodified **metal radical** 金 jīn.

Which component comes first?

Left 钅 then right 甫.

Tips on stroke order

Minor strokes are written last.

Practise writing the character.

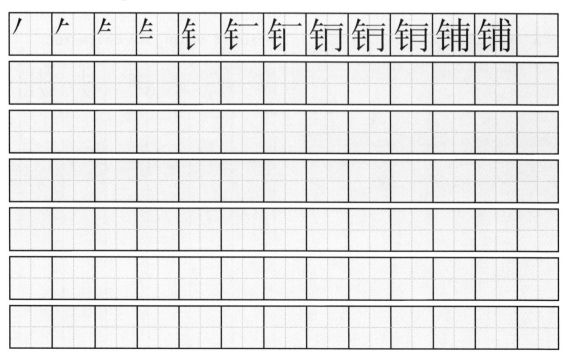

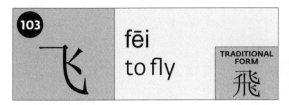

103 飞 fēi to fly — TRADITIONAL FORM 飛

Examples
飞机 fēijī airplane
飞机票 fēijīpiào plane ticket
飞机场 fēijīchǎng airport

More about radicals
The **second radical** is not associated with meaning. It takes a variety of forms. It appears as ㇟ in 飞 (to fly), as ㇆ in 买 mǎi (to buy) [120] and 书 shū (book) [177], and as ㇄ in 孔 kǒng (Confucius) [179].

Lost in simplification
The traditional form represents **ascent** (升 shēng) by **wings** (double 飞 fēi).

● ●

Practise writing the character.

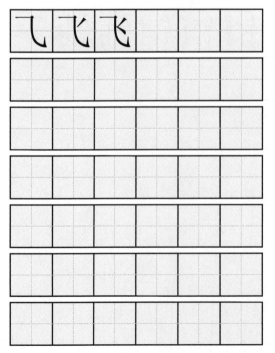

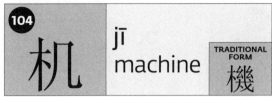

104 机 jī machine — TRADITIONAL FORM 機

Character information
This character combines the **wood radical** 木 mù to indicate meaning, with the **phonetic** 几 jǐ (several) to indicate sound.

Examples
计算机 jìsuànjī computer
手机 shǒujī mobile phone
机会 jīhuì opportunity

More about radicals
You can read about the **wood radical** 木 mù by turning back to character [77].

Which component comes first?
Left 木 then right 几.

● ●

Practise writing the character.

105

际 jì
border

TRADITIONAL FORM
際

Character information

This character combines the **mound radical** 阝 to indicate meaning, with 示 shì (to show).

Example

国际 guójì international

More about radicals

The **mound radical** 阝 (modified from 阜 fù) appears on the left side of some characters, such as 院 yuàn (courtyard) [113]. Note that it looks identical to the **town radical**, which appears on the right side. Turn back to character [72] to read more about the **town radical**.

Lost in simplification

The traditional form contains the **phonetic** 祭 jì (to offer a sacrifice), which has been lost in the simplification process.

Which component comes first?

Left 阝 then right 示.

Tips on stroke order

Centre strokes are written before outside strokes.

Practise writing the character.

106 登 dēng
to go up

Character information

This character combines the **bean radical** 豆 dòu with 癶.

Examples

登机 dēngjī to board a plane
登机牌 dēngjīpái boarding pass
登录 dēnglù to log on (to a website)

More about radicals

You can read about the **bean radical** 豆 dòu by turning forward to character [146].

Which component comes first?

Upper 癶 then lower 豆.

Tips on stroke order

Bottom horizontal strokes are written last.

Practise writing the character.

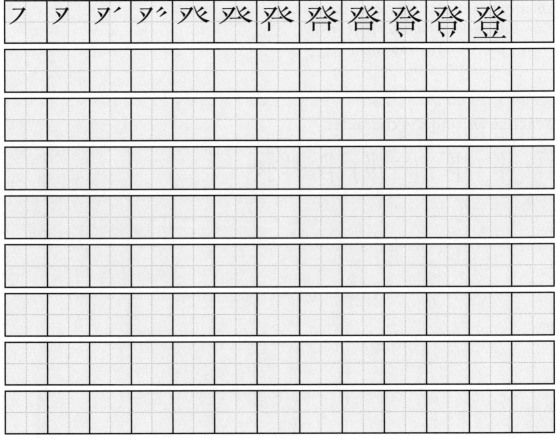

About town

This section focuses on characters that are used in words that relate to buildings and services that you will find in all Chinese towns and cities: from Internet cafes and pubs, to hospitals and post offices.

Perhaps the most helpful radical introduced in this section is the food radical. It first appears in the book as a component of the character 馆 guǎn [115], which is used to make the words for *restaurant* and *teahouse*, amongst others.

In this section, you will learn how to write the following characters, and be introduced to the following radicals:

No.	Chinese	Pinyin	English	Radical introductions
107	公	gōng	public	
108	网	wǎng	net	The open country radical 冂
109	医	yī	doctor; medicine	
110	吧	ba	auxiliary word	
111	局	jú	department; office	The corpse radical 尸
112	厕	cè	toilet	
113	院	yuàn	courtyard	
114	银	yín	silver	
115	馆	guǎn	place	The food radical 食(饣)
116	街	jiē	street	
117	路	lù	road	The foot radical 𧾷

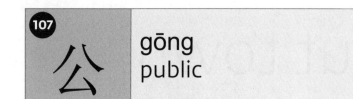

107

公 gōng
public

Character information
This character represents the **division** (八 bā) of **private property** (厶 sī).

Examples
公安局 gōng'ānjú Public Security Bureau
公厕 gōngcè public toilet
公共汽车 gōnggòng qìchē bus
公里 gōnglǐ kilometre

More about radicals
You can read about the **divide radical** 八 bā by turning back to character [33].

Good to know!
Foreigners who wish to extend their visas in China should go to the Public Security Bureau. There is one in every town.

Which component comes first?
Upper 八 then lower 厶.

Practise writing the character.

丿 八 公 公

108

网

wǎng
net

TRADITIONAL FORM

網

Character information
This character looks like a **net**.

Examples
网吧　wǎngbā　Internet café
网页　wǎngyè　web page
网球　wǎngqiú　tennis

More about radicals
The **open country radical** 冂 is associated with **boundaries**. This component also appears in 两 liǎng (two) [36], 内 nèi (inside) [58], 南 nán (south) [66] and 再 zài (again) [212]. But, experts disagree about which radical they are grouped under.

Lost in simplification
The traditional form uses the **silk radical** 糹. To read more about the silk radical, turn forward to character [191].

Good to know!
Public Internet cafés are very inexpensive and popular places for young Chinese people to spend their free time playing interactive computer games or chatting to friends online. Look out for 网吧 signs in the street. You may be asked to show your passport.

Which component comes first?
Outer 冂 then inner.

Tips on stroke order
Enclosing strokes are written before enclosed strokes.

Be careful!
Be careful not to confuse it with 风 fēng [168].

Practise writing the character.

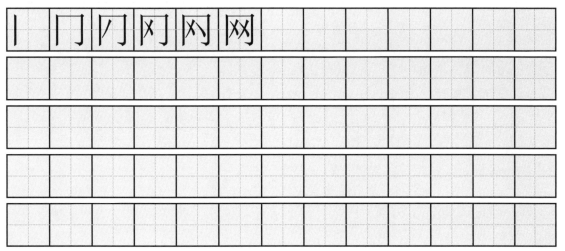

109

医
yī
doctor; medicine

TRADITIONAL FORM
醫

Character information

This character combines the **box radical** 匚 with 矢 shǐ (arrow).

Examples

医生 yīshēng doctor
医药 yīyào medicine
医院 yīyuàn hospital

Lost in simplification

The components of the traditional form represent **shooting arrows** (at a disease) and **alcohol** (for sterilising).

Tips on stroke order

Notice how you write 矢 under the first stroke of the open box before writing the side and bottom of the box in one stroke.

• •

Practise writing the character.

一	厂	厈	歫	歫	矢	医							

110

吧

ba
auxiliary word

Character information
This character combines the **mouth radical** 口 kǒu to indicate meaning, with the **phonetic** 巴 bā (to hope) to indicate sound.

Examples
酒吧　jiǔbā　bar; pub
网吧　wǎngbā　Internet café

More about radicals
You can read about the **mouth radical** 口 kǒu by turning back to character [3].

More about phonetics
巴 bā (to hope) functions as a phonetic in 爸 bà (father) [20].

Good to know!
吧 bā at the end of a sentence forms a suggestion. For example: 我们回家吧。Wǒmen huíjiā ba. **Let's go home**.

Which component comes first?
Left 口 then right 巴.

• •

Practise writing the character.

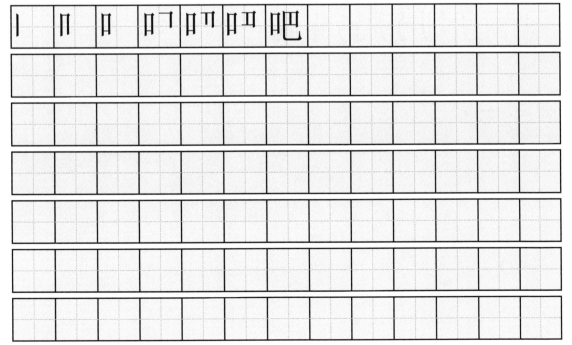

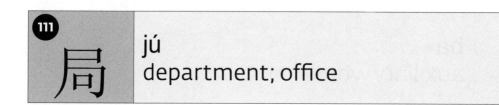

111

局

jú
department; office

Character information
This character represents **measurements** (尺 chǐ) and **reports** (口 kǒu).

Examples
邮局 yóujú post office
公安局 gōng'ānjú Public Security Bureau

More about radicals
The **corpse radical** 尸 shī does not provide any meaning in this character, as it is a modification of the original component 尺 chǐ (measurement).

Which component comes first?
Upper 尸, centre then inner 口.

Tips on stroke order
Enclosing strokes are written before enclosed strokes.

Practise writing the character.

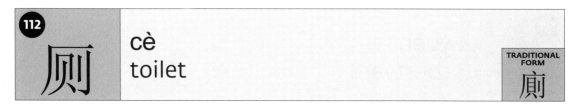

112

厕

cè
toilet

TRADITIONAL
FORM

廁

Character information

This character combines the **cliff radical** 厂 chǎng to indicate meaning, with the **phonetic** 则 zé (rule) to indicate sound.

Examples

厕所 cèsuǒ toilet
男厕 náncè men's toilet
女厕 nǚcè women's toilet

Lost in simplification

The traditional form of the character uses the **shelter radical** 广 guǎng, which provides a better clue to the meaning, as it does in 店 diàn (shop) [122] and 床 chuáng (bed) [166].

Which component comes first?

Outer 厂 then inner (贝 then 刂).

Practise writing the character.

113

院 yuàn
courtyard

Character information

This character combines the **mound radical** 阝 to indicate meaning, with the **phonetic** 完 wán (whole) to indicate sound.

More about radicals

You can read about the **mound radical** 阝 by turning back to character [105].

Which component comes first?

Left 阝 then right 完.

Examples

院子 yuànzi courtyard
电影院 diànyǐngyuàn cinema
剧院 jùyuàn theatre
医院 yīyuàn hospital
学院 xuéyuàn college

Practise writing the character.

114

银

yín
silver

TRADITIONAL FORM
銀

Character information

This character combines the **metal radical** 钅 to indicate meaning, with the **phonetic** 艮 gěn (tough) to indicate sound.

Examples

银行　yínháng　bank
收银台　shōuyíntái　cashier's desk

More about radicals

You can read about the **metal radical** 钅 by turning back to character [40].

More about phonetics

艮 gěn functions as a **phonetic** in 很 hěn (very), 恨 hèn (to hate) and 眼 yǎn (eye).

Which component comes first?

Left 钅 then right 艮.

Practise writing the character.

| ノ | ノ | 丿 | 钅 | 钅 | 钅 | 钅 | 钅 | 钅 | 钅 | 钅 | |

115

馆

guǎn
place

Character information

This character combines the **food radical** 饣 to indicate meaning, with the **phonetic** 官 guān (official) to indicate sound.

Examples

宾馆 bīnguǎn hotel
博物馆 bówùguǎn museum
茶馆 cháguǎn teahouse
大使馆 dàshǐguǎn embassy
饭馆 fànguǎn restaurant
图书馆 túshūguǎn library

More about radicals

Associated with **eating and drinking**, the **food radical** 饣 (modified from 食 shí) appears in 饭 fàn (food) [138] and 饮 yǐn (to drink) [139].

More about phonetics

官 guān functions as a **phonetic** in 管 guǎn (tube; to be in charge of).

Which component comes first?

Left 饣 then right 官.

Tips on stroke order

Bottom horizontal strokes are written last.

● ●

Practise writing the character.

116

街 jiē
street

Character information

This character combines the **step radical** 彳 to indicate meaning, with 圭 guī (jade tablet) and 亍 chù (to step).

Examples

大街 dàjiē street
逛街 guàngjiē to go shopping
长安街 Cháng'ānjiē Chang'an Avenue

More about radicals

You can read about the **step radical** 彳 by turning back to character [84].

Good to know!

Chang'an Avenue (also known as the Avenue of Eternal Peace) runs east-west through the centre of Beijing. Many important landmarks are found along this avenue, including Tian'anmen Square, the entrance to the Forbidden City, Beijing Concert Hall and Wangfujing shopping street.

Which component comes first?

Left 彳, centre 圭 then right 亍.

Be careful!

Be careful not to confuse it with 行 xíng (to walk) [84].

Practise writing the character.

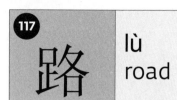

117

路 lù
road

Character information
This character represents **feet** (足 zú) travelling in **different** (各 gè) **directions**.

Examples
路标 lùbiāo signpost
路口 lùkǒu crossing
走路 zǒulù to walk
过马路 guò mǎlù to cross the street

More about radicals
The **foot radical** 足 (modified from 足 zú) is associated with **movement**. It appears in 跑 pǎo (to run) and 跳 tiào (to jump).

Good to know!
You can say 一路平安 yí lù píng'ān to **wish someone a safe journey**.

Which component comes first?
Left 足 then right 各.

Tips on stroke order
Bottom horizontal strokes are written last.

Practise writing the character.

Shopping

The characters in this section will be very useful for your shopping outings while you are in China (or Chinatown). Two common measure words are introduced in this section. You will see and use 元 yuán [118] and 斤 jīn [119] every time you go to the market and want to talk about prices or the weight of your groceries. Notice how the pronunciations of the characters for *buy* (mǎi) and *sell* (mài) are very similar. If you haven't already realised, this should convince you of the importance of getting the tones right!

In this section, you will learn how to write the following characters, and be introduced to the following radicals:

No.	Chinese	Pinyin	English	Radical introductions
118	元	yuán	first; measure word	
119	斤	jīn	unit of weight (equal to 500g); measure word	The axe radical 斤
120	买	mǎi	to buy	
121	卖	mài	to sell	
122	店	diàn	shop	The shelter radical 广
123	品	pǐn	article	
124	贵	guì	expensive	The shell radical 贝
125	钱	qián	money	
126	商	shāng	to discuss; commerce	
127	超	chāo	to exceed; super	

118

元 yuán
first; measure word

Character information
This character represents the **head** (二 èr) of a **person** (儿 ér).

Examples
元旦 Yuándàn New Year's Day
元宵 yuánxiāo glutinous rice balls
元宵节 Yuánxiāo Jié the Lantern Festival
五元钱 wǔ yuán qián five *yuan*

More about radicals
You can read about the **two radical** 二 èr by turning back to character [27].

More about phonetics
元 yuán functions as a **phonetic** in 院 yuàn (courtyard) [113], 园 yuán (garden) and 远 yuǎn (far).

Good to know!
The Lantern Festival is celebrated on the 15th day of the first month in the lunar calendar. The festival marks the end of the Chinese New Year festivities and takes place under a full moon. The traditional food which is eaten at this festival is called 元宵 yuánxiāo or 汤圆 tāngyuán, a round dumpling made from glutinous rice flour with various, usually sweet, fillings.

Which component comes first?
Upper 二 then lower 儿.

Practise writing the character.

一	二	元	元							

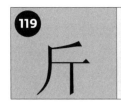

119

jīn
unit of weight (equal to 500g); measure word

Character information
This character looks like an **axe**.

Examples
三斤苹果 sān jīn píngguǒ three *jin* of apples (roughly 1.5kg)
公斤 gōngjīn kilogram

More about radicals
The **axe radical** 斤 jīn also appears in 新 xīn (new) [219]. The meaning is sometimes associated with an **axe** or **chopping**, such as 断 duàn (to break).

Practise writing the character.

一 厂 斤 斤

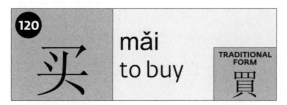

Character information

This character combines the **second radical** ﹁ with 头 tóu (head).

Example

买东西 mǎi dōngxi to go shopping

More about radicals

You can read about the **second radical** ﹁ by turning back to character [103].

Lost in simplification

The traditional form of the character represents the meaning by combining components for **shells** (贝 bèi), which were an old form of currency, and **catch with a net** (罒).

Good to know!

To ask for the bill in a Chinese restaurant say 买单！ Mǎidān!

Practise writing the character.

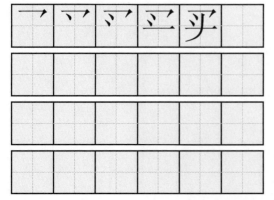

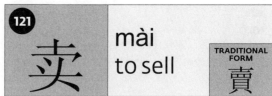

Character information

This character combines the **cross radical** 十 shí with 买 mǎi (to sell).

Examples

外卖 wàimài takeaway (food)
小卖部 xiǎomàibù small shop

More about radicals

You can read about the **cross radical** 十 shí by turning back to character [35].

Be careful!

Be careful not to confuse 买 mǎi (to buy) and 卖 mài (to sell).

Practise writing the character.

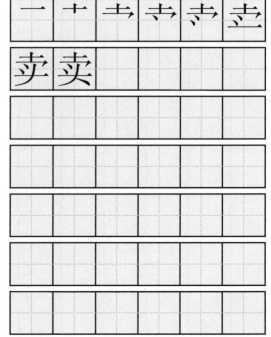

122

店

diàn
shop

Character information

This character combines the **shelter radical** 广 guǎng to indicate meaning, with the **phonetic** 占 zhàn (to consitute) to indicate sound.

Examples

饭店 fàndiàn hotel; restaurant
商店 shāngdiàn shop
书店 shūdiàn bookshop
药店 yàodiàn chemist's

More about radicals

The **shelter radical** 广 guǎng is associated with **large** or **occupied spaces**. It appears in 麻 má (numb) [154], 床 chuáng (bed) [166], and 度 dù (degree) [173].

More about phonetics

占 zhàn functions as a **phonetic** in 点 diǎn (o'clock) [39] and 站 zhàn (to stand) [96].

Which component comes first?

Upper 广 then lower 占.

Tips on stroke order

Bottom horizontal strokes are written last.

Practise writing the character.

`	亠	广	广	庐	庐	店	店						

123

品 pǐn
article

Character information

This character represents a collection of **containers** (口 kǒu).

More about radicals

You can read about the **mouth radical** 口 kǒu by turning back to character [3].

Examples

产品 chǎnpǐn product
工艺品 gōngyìpǐn handicraft
纪念品 jìniànpǐn souvenir
商品 shāngpǐn merchandise

Which component comes first?

Upper 口 then lower (left 口 then right 口).

• •

Practise writing the character.

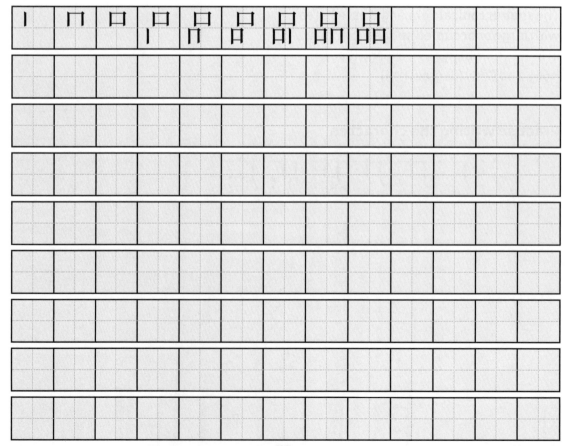

124

贵

guì
expensive

TRADITIONAL
FORM

貴

Character information
This character represents a basket of **shells** (贝 bèi).

Examples
贵宾 guìbīn honourable guest
宝贵 bǎoguì valuable

More about radicals
The **shell radical** 贝 bèi is associated with **money** (shells were an old form of currency). It appears in 财 cái (wealth), 账 zhàng (accounts) and 购 gòu (to buy).

Good to know!
It is common to barter when buying from outdoor markets. If you want the price to be lowered say 太贵了！Tài guì le! which means **that's way too expensive!**

Which component comes first?
Upper 中, centre 一 then lower 贝.

Tips on stroke order
Enclosing strokes are written before enclosed strokes.

Practise writing the character.

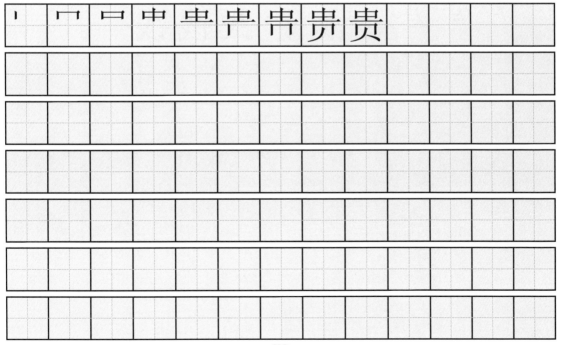

shopping

125

钱

qián
money

TRADITIONAL
FORM

錢

Character information

This character combines the **metal radical** 钅 to indicate meaning, with the **phonetic** 戋 jiān (narrow) to indicate sound.

Examples

钱包 qiánbāo wallet
价钱 jiàqian price
四块钱 sì kuài qián 4 *yuan*

More about radicals

You can read about the **metal radical** 钅 by turning back to character [40].

More about phonetics

戋 jiān functions as a **phonetic** in 线 xiàn (thread).

Good to know!

To **ask the price** of something say 多少钱？ duōshǎo qián?

Which component comes first?

Left 钅 then right 戋.

Tips on stroke order

Minor strokes are written last.

Practise writing the character.

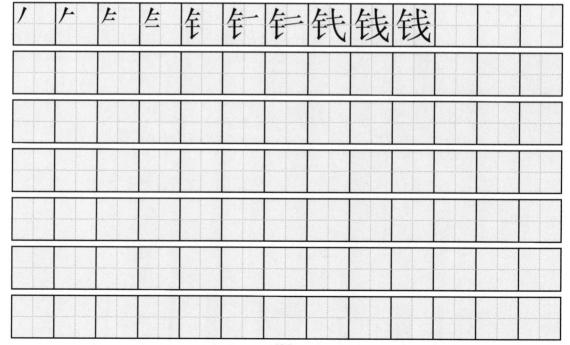

126 商

shāng
to discuss; commerce

Character information
This character combines the **lid radical** ⼇ with ⼋ bā (eight) and 冏 jiǒng (bright).

Examples
商店 shāngdiàn shop
商量 shāngliang to discuss
商人 shāngrén businessman;
 businesswoman

More about radicals
You can read about the **lid radical** ⼇ by turning back to character [31].

Which component comes first?
Upper ⼇, centre ⼋ then lower 冏.

Tips on stroke order
Enclosing strokes are written before enclosed strokes.

• •

Practise writing the character.

127

超

chāo
to exceed; super

Character information

This character combines the **run radical** 走 zǒu to indicate meaning, with the **phonetic** 召 zhào (to convene) to indicate sound.

Examples

超市 chāoshì supermarket
超短裙 chāoduǎnqún miniskirt

More about radicals

You can read about the **run radical** 走 zǒu by turning back to character [88].

More about phonetics

You can read about the 召 zhào **phonetic** by turning back to character [97].

Which component comes first?

Left 走 then right 召.

Tips on stroke order

Bottom enclosing strokes are written after enclosed strokes.

Practise writing the character.

Restaurants and hotels

The examples in this section include many words that are essential when communicating with the staff in a restaurant or at your hotel. After practising writing the characters in this section, you will be able to recognize many items of food on menus in Chinese restaurants. For many travellers, this is one of the biggest daily challenges which prevents them from enjoying local food at local prices.

In this section, you will learn how to write the following characters, and be introduced to the following radicals:

No.	Chinese	Pinyin	English	Radical introductions
128	吃	chī	to eat	
129	喝	hē	to drink	
130	水	shuǐ	water	The water radical 水(氵)
131	洗	xǐ	to wash	
132	酒	jiǔ	alcohol	
133	煮	zhǔ	to boil	
134	蒸	zhēng	to steam	The grass radical 艹
135	炒	chǎo	to stir-fry	
136	烤	kǎo	to roast	
137	餐	cān	meal	
138	饭	fàn	meal; food	
139	饮	yǐn	to drink	
140	苹	píng	apple	
141	茄	qié	aubergine	
142	茶	chá	tea	
143	菜	cài	vegetable	
144	米	mǐ	rice; metre	The rice radical 米
145	肉	ròu	meat	
146	豆	dòu	bean	The bean radical 豆
147	面	miàn	surface; flour	
148	鸡	jī	chicken	The bird radical 鸟
149	鸭	yā	duck	
150	鱼	yú	fish	The fish radical 鱼
151	虾	xiā	shrimp	The insect radical 虫
152	梨	lí	pear	
153	咸	xián	salted	
154	麻	má	hemp; numb	
155	辣	là	hot	
156	凉	liáng	cool	The ice radical 冫
157	快	kuài	fast	
158	筷	kuài	chopsticks	The bamboo radical 𥫗
159	杯	bēi	cup; glass	
160	锅	guō	pot	
161	碗	wǎn	bowl	
162	员	yuán	employee	
163	住	zhù	to live	
164	间	jiān	room	The gate radical 门
165	房	fáng	house; room	
166	床	chuáng	bed	

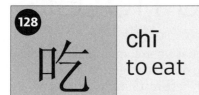

128

吃 chī
to eat

Character information

This character combines the **mouth radical** 口 kǒu to indicate meaning, with the **phonetic** 乞 qǐ (to beg) to indicate sound.

Examples

吃醋 chīcù to be jealous
吃饭 chīfàn to have a meal
吃药 chīyào to take medicine
好吃 hǎochī delicious

More about radicals

You can read about the **mouth radical** 口 kǒu by turning back to character [3].

Good to know!

In Chinese, the phrase **to be jealous** literally translates as eat (吃 chī) vinegar (醋 cù).

Which component comes first?

Left 口 then right 乞.

Practise writing the character.

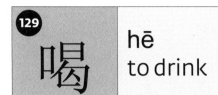

129

喝

hē
to drink

Character information

This character combines the **mouth radical** 口 kǒu to indicate meaning, with the **phonetic** 曷 hé (why?) to indicate sound.

Example

喝咖啡 hē kāfēi to drink coffee

More about radicals

You can read about the **mouth radical** 口 kǒu by turning back to character [3].

Which component comes first?

Left 口 then right 曷.

Tips on stroke order

Bottom enclosing strokes are written after enclosed strokes.

Practise writing the character.

130

水

shuǐ
water

Character information

This character looks like **flowing water**.

Examples

水果 shuǐguǒ fruit
水饺 shuǐjiǎo boiled dumpling
洗发水 xǐfàshuǐ shampoo

More about radicals

The **water radical** (水 modified to 氵) is associated with **water**. It appears in 湖 hú (lake) [80], 海 hǎi (sea) [82], or 洗 xǐ (to wash) [131].

Tips on stroke order

Centre strokes are written before outside strokes.

Practise writing the character.

131

洗

xǐ
to wash

Character information

This character combines the **water radical** 氵 to indicate meaning, with the **phonetic** 先 xiān (first) to indicate sound.

Examples

洗手间 xǐshǒujiān toilet
洗衣机 xǐyījī washing machine
洗澡 xǐzǎo to take a shower

More about radicals

You can read about the **water radical** 氵 by turning back to character [130].

Which component comes first?

Left 氵 then right 先.

Practise writing the character.

restaurants and hotels

132

酒 jiǔ
alcohol

Character information

This character combines the **water radical** 氵 to indicate meaning, with the **phonetic** 酉 yǒu (a classical word for alcohol, which also looks like a vase) to indicate sound.

Examples

酒吧 jiǔbā bar; pub
白酒 báijiǔ Chinese spirits (distilled from sorghum)
啤酒 píjiǔ beer
葡萄酒 pútaojiǔ wine

More about radicals

You can read about the **water radical** 氵 by turning back to character [130].

Which component comes first?

Left 氵 then right 酉.

Tips on stroke order

Bottom horizontal strokes are written last.

Be careful!

Be careful not to confuse the component 酉 with 西 xī (west) [67] or 四 sì (four) [29].

Practise writing the character.

133

煮

zhǔ
to boil

Character information
This character combines the **fire radical**
灬 to indicate meaning, with the **phonetic**
者 zhě (person) to indicate sound.

Examples
煮饭 zhǔfàn to cook
煮咖啡 zhǔkāfēi to brew coffee
煮饺子 zhǔjiǎozi to cook Chinese
 dumplings

More about radicals
You can read about the **fire radical** 灬
by turning forward to character [220].

Good to know!
生米煮成熟饭 shēngmǐ zhǔchéng shúfàn is
a saying which literally means raw rice has
turned into cooked rice. It describes
a change which cannot be reversed.

Which component comes first?
Upper 者 then lower 灬.

Practise writing the character.

134

蒸

zhēng
to steam

Character information

This character combines the **grass radical** 艹 to indicate meaning, with the **phonetic** 烝 zhēng (to rise; to steam) to indicate sound.

Examples

蒸包子 zhēngbāozi to steam stuffed buns
蒸馒头 zhēngmántou to steam bread rolls
蒸鱼 zhēngyú steamed fish

More about radicals

The **grass radical** 艹 is associated with **plants**. It appears in 苹 píng (apple) [140], 茄 qié (aubergine) [141] and 茶 chá (tea) [142]. In the case of 蒸 **burned grass** produces **steam**.

Lost in simplification

The **grass radical** 艹 has been modified from the traditional form 艸 cǎo, which looks like **grass**.

Which component comes first?

Upper 艹 then lower (丞 then 灬).

● ●

Practise writing the character.

一	十	艹	艻	艿	芽	莁	莁	茐	茐	蒸	蒸	蒸

135

炒 chǎo
to stir-fry

Character information

This character combines the **fire radical** 火 huǒ to indicate meaning, with the **phonetic** 少 shǎo (few) to indicate sound.

Examples

炒菜 chǎocài to stir-fry
炒饭 chǎofàn stir-fried rice
炒面 chǎomiàn stir-fried noodles

More about radicals

You can read about the **fire radical** 火 by turning forward to character [220].

More about phonetics

少 shǎo functions as a **phonetic** in 秒 miǎo (second of time) and 沙 shā (sand).

Good to know!

炒鱿鱼 chǎo yóuyú is a phrase which means **to be sacked**. It literally translates as stir-fried squid.

Which component comes first?

Left 火 then right 少.

Tips on stroke order

Centre strokes are written before outside strokes.

Practise writing the character.

136

kǎo
to roast

Character information

This character combines the **fire radical** 火 huǒ to indicate meaning, with the **phonetic** 考 kǎo (to have an exam) to indicate sound.

Examples

烤鸭 kǎoyā roast duck
烤炉 kǎolú oven
烤面包 kǎomiànbāo toast

More about radicals

You can read about the **fire radical** 火 by turning forward to character [220].

Which component comes first?

Left 火 then right 考.

• •

Practise writing the character.

`	``	少	火	灯	灶	灶	烤	烤	烤			

137

餐

cān
meal

Character information

This character combines the **food radical** 食 shí to indicate meaning, with a classical word for **crush**.

Examples

餐厅 cāntīng canteen; restaurant
午餐 wǔcān lunch

More about radicals

The **food radical** 食 shí is more commonly modified to 饣. Read more by turning back to character [115].

Good to know!

As a foreigner in China, locals who invite you out to dinner will often ask whether you would like to eat 西餐 xīcān **western food** or 中餐 zhōngcān **Chinese food**.

Which component comes first?

Upper then lower.

Practise writing the character.

⼘	⼙	广	歩	歩	歩丁	歩又	歩又	歺	歺	歺	餐	餐
餐	餐	餐										

138

饭

fàn
meal; food

TRADITIONAL FORM

飯

Character information

This character combines the **food radical** 饣 to indicate meaning, with the **phonetic** 反 fǎn (reverse) to indicate sound.

Examples

饭店　fàndiàn　hotel; restaurant
饭馆　fànguǎn　restaurant
晚饭　wǎnfàn　evening meal

More about radicals

You can read about the **food radical** 饣 by turning back to character [115].

Which component comes first?

Left 饣 then right 反.

• •

Practise writing the character.

| 丿 | 𠂊 | 饣 | 饣 | 饣 | 饭 | 饭 | | | | | | | |

139 饮

yǐn
to drink

Character information

This character combines the **food radical**
饣 to indicate meaning, with the **phonetic**
欠 qiàn (to owe) to indicate sound.

Examples

饮料 yǐnliào drink
饮食 yǐnshí food and drink

More about radicals

You can read about the **food radical** 饣
by turning back to character [115].

Which component comes first?

Left 饣 then right 欠.

Tips on stroke order

Left falling strokes are written before right
falling strokes.

Practise writing the character.

ノ	𠂇	饣	饮	饮	饮	饮						

140

píng
apple

TRADITIONAL FORM

Character information
This character combines the **grass radical** ⁺⁺ to indicate meaning, with the **phonetic** 平 píng (flat; peace) to indicate sound.

Examples
苹果 píngguǒ apple

More about radicals
You can read about the **grass radical** ⁺⁺ by turning back to character [134].

More about phonetics
平 píng functions as a **phonetic** in 评 píng (criticise).

Which component comes first?
Upper ⁺⁺ then lower 平.

Lost in simplification
The traditional form contains the **phonetic** 頻 pín (frequently).

Tips on stroke order
Horizontal strokes are written before vertical strokes.

Practise writing the character.

141

茄

qié
aubergine

Character information

This character combines the **grass radical** ⼗⼗ to indicate meaning, with the **phonetic** 加 jiā (to add) to indicate sound.

Examples

茄子 qiézi aubergine
鱼香茄子 yúxiāngqiézi "fish flavoured" aubergine in garlic sauce

More about radicals

You can read about the **grass radical** ⼗⼗ by turning back to character [134].

More about phonetics

加 jiā functions as a **phonetic** in 架 jià (frame) and 驾 jià (to drive).

Which component comes first?

Upper ⼗⼗ then lower 加.

Practise writing the character.

一 十 卄 艹 艻 茄 茄 茄

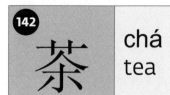

142

茶 chá
tea

Character information
This character combines the **grass radical**
⁺⁺ to indicate meaning, with a modified
version of 余 yú (extra).

Examples
红茶 hóngchá black tea
茶壶 cháhú teapot
茶叶 cháyè tea leaves
绿茶 lǜchá green tea

More about radicals
You can read about the **grass radical** ⁺⁺
by turning back to character [134].

Good to know!
Although you can still find traditional 茶馆
cháguǎn **teahouses** around China, you will
also see many **cafés**. Look for signs that
say 咖啡厅 kāfēitīng.

Which component comes first
Upper ⁺⁺ then lower.

Tips on stroke order
Centre strokes are written before outside
strokes.

Practise writing the character.

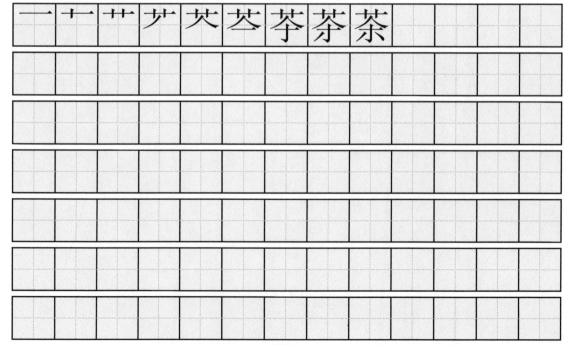

143

菜 cài
vegetable

Character information

This character combines the **grass radical** 艹 to indicate meaning, with the **phonetic** 采 cǎi (to pick) to indicate sound.

Examples

菜单 càidān menu
白菜 báicài Chinese cabbage
菠菜 bōcài spinach
点菜 diǎncài to order food
青菜 qīngcài green vegetable

More about radicals

You can read about the **grass radical** 艹 by turning back to character [134].

More about phonetics

采 cǎi functions as a **phonetic** in 彩 cǎi (colour).

Which component comes first

Upper 艹 then lower 采.

Tips on stroke order

Centre strokes are written before outside strokes.

Practise writing the character.

一	十	艹	艹	芣	苹	苹	苹	苹	菜	菜		

144

米 mǐ
rice; metre

145

肉 ròu
meat

Character information

Looks like some **grains of rice**.

Examples

米饭 mǐfàn cooked rice
大米 dàmǐ uncooked rice
一米长 yī mǐ cháng one metre long

More about radicals

The **rice radical** 米 is associated with **rice** or **grain**. It appears in 粮 liáng (grain) and 糖 táng (sugar).

Be careful!

Be careful not to confuse it with 来 lái (to come) [87].

Character information

This character looks like an **animal's ribcage**.

Examples

鸡肉 jīròu chicken meat
牛肉 niúròu beef
羊肉 yǎngròu lamb meat
猪肉 zhūròu pork

More about radicals

You can read about the **line radical** │ by turning back to character [58].

Be careful!

Be careful not to confuse it with 两 liǎng (two) [36] or 内 nèi (inside) [58].

Practise writing the character.

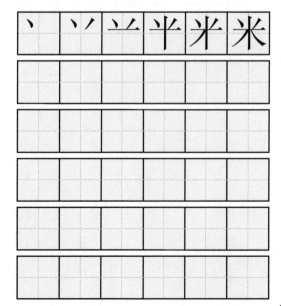

Practise writing the character.

146

豆 dòu
bean

Character information
This character looks like a **ceremonial dish on a stand**.

Examples
豆子 dòuzi bean
豆腐 dòufu tofu
豌豆 wāndòu pea
土豆 tǔdòu potato

More about radicals
The **bean radical** 豆 dòu also appears in 登 dēng (to go up) [106].

More about phonetics
豆 dòu functions as a **phonetic** in 燈, which is the traditional form of 灯 dēng (light) [190], and 短 duǎn (short).

Which component comes first?
Upper 一 , centre 口 then lower.

Tips on stroke order
Bottom horizontal strokes are written last.

Practise writing the character.

147

面

miàn
surface; flour

TRADITIONAL FORM

麵

Character information

This character looks like a **face** (notice how 目 mù, which means **eye**, sits inside 囗 wéi).

Examples

面条 miàntiáo noodles
拉面 lāmiàn pulled noodles
对面 duìmiàn opposite
见面 jiànmiàn to meet

More about radicals

You can read about the **one radical** 一 yī by turning back to character [26].

Lost in simplification

面 means **surface** in both simplified and traditional forms. However, the traditional form for **flour** is 麵, which contains the **wheat radical** (麥 mài).

Tips on stroke order

Enclosing strokes are written before enclosed strokes. Bottom horizontal strokes are written last.

Practise writing the character.

148

鸡 jī
chicken

TRADITIONAL FORM
雞

Character information

This character combines the **bird radical** 鸟 niǎo to indicate meaning, with 又 yòu (again).

Examples

鸡蛋 jīdàn chicken egg
鸡肉 jīròu chicken meat
火鸡 huǒjī turkey

More about radicals

The **bird radical** 鸟 niǎo looks like a **bird**. It also appears in 鸭 yā (duck) [149].

Lost in simplification

The components of the traditional form represent **servant** (奚 xī) **short-tailed bird** (隹 zhuī).

Which component comes first?

Left 又 then right 鸟.

• •

Practise writing the character.

149

鸭

yā
duck

TRADITIONAL FORM

鴨

Character information

This character combines the **bird radical** 鸟 niǎo to indicate meaning, with the **phonetic** 甲 jiǎ (armour) to indicate sound.

More about radicals

The **bird radical** 鸟 niǎo also appears in 鸡 jī (chicken) [148].

Which component comes first?

Left 甲 then right 鸟.

Example

烤鸭 kǎoyā roast duck

• •

Practise writing the character.

150

鱼

yú
fish

TRADITIONAL FORM

魚

Character information

This character looks like a **fish**.

Examples

金枪鱼 jīnqiāngyú tuna
鱿鱼 yóuyú squid
一条鱼 yī tiáo yú one fish

More about radicals

The **fish radical** 鱼 yú looks like a **fish**.
It also appears in 鱿 yóu (cuttlefish) and
鲜 xiān (fresh).

Good to know!

条 tiáo is a **measure word** used with long
objects such as 鱼 yú (fish), 路 lù (road)
[117], 狗 gǒu (dog), and 河 hé (river) [79].

Which component comes first?

Upper, centre 田 then lower 一.

Practise writing the character.

151

虾

xiā
shrimp

TRADITIONAL
FORM

蝦

Character information

This character combines the **insect radical** 虫 chóng to indicate meaning, with the **phonetic** 下 xià (below) to indicate sound.

Examples

对虾 duìxiā prawn
龙虾 lóngxiā lobster

More about radicals

The **insect radical** 虫 chóng appears in other characters related to insects or lizards, such as 蛇 shé (snake) and 蚊 wén (mosquito).

Lost in simplification

The traditional form uses the **phonetic** 叚 jiǎ (borrow), but in the simplification process this component is actually improved. Not only is the **phonetic** 下 xià easier to write, but is also a better approximation of the sound.

Which component comes first?

Left 虫 then right 下.

Practise writing the character.

152

梨 lí
pear

Character information

This character combines the **wood radical** 木 mù to indicate meaning, with the **phonetic** 利 lì (advantage) to indicate sound.

Example

梨子 lízi pear

More about radicals

You can read about the **wood radical** 木 mù by turning back to character [77].

Good to know!

Chinese people think it is unlucky to share a pear, as 梨 lí sounds the same as 离 lí (to part from).

Which component comes first?

Upper 利 then lower 木.

Tips on stroke order

Centre strokes are written before outside strokes.

• •

Practise writing the character.

153

xián
salted

Example
咸菜 xiáncài pickled vegetables

More about radicals
You can read about the **mouth radical** 口 kǒu by turning back to character [3].

Lost in simplification
The traditional form combines the **salt radical** 鹵 lǔ to indicate meaning, with the **phonetic** 咸 xián (all) to indicate sound. The simplified form does away with the radical, leaving the phonetic to stand alone and take on a new meaning.

Tips on stroke order
Minor strokes are written last.

Be careful!
Be careful not to confuse it with 城 chéng (city; town) [69].

Practise writing the character.

一 厂 厂 厍 戌 咸 咸 咸 咸

154

麻

má
hemp; numb

Character information

This character represents **hemp plants** (林 lín) drying under **shelter** (广 guǎng).

Examples

麻将 májiàng mah jong
麻花 máhuā fried dough twist
麻婆豆腐 mápódòufu stir-fried tofu in chilli sauce
芝麻 zhīma sesame seed

More about radicals

You can read about the **shelter radical** 广 guǎng by turning back to character [122].

Good to know!

花椒 huājiāo **Sichuan pepper** is added to chilli sauces in Sichuanese cuisine and produces a tingling and numb sensation (麻 má) in the mouth.

Which component comes first?

Outer 广 then inner 林.

Practise writing the character.

丶	一	广	广	庁	庁	床	庈	庈	麻	麻		

155

辣

là
hot

Character information

This character combines the **bitter radical** 辛 xīn to indicate meaning, with 束 shù (to bind).

Examples

辣酱 làjiàng chilli sauce
辣椒 làjiāo chillies

Which component comes first?

Left 辛 then right 束.

Tips on stroke order

Centre strokes are written before outside strokes.

· ·

Practise writing the character.

丶	宀	宀	立	立	立	辛	辛	辛	辣	辣	辣	辣
辣												

156

涼

liáng
cool

Character information
This character combines the **ice radical** 冫 to indicate meaning, with the **phonetic** 京 jīng (capital) to indicate sound.

Examples
凉菜 liángcài cold dish
凉快 liángkuai pleasantly cool (weather)
凉面 liángmiàn cold noodles in sauce

More about radicals
The **ice radical** 冫 looks like ice crystals. It appears in characters such as 冷 lěng (cold) [171], 冰 bīng (ice) and 冻 dòng (freeze).

More about phonetics
京 jīng (capital) [71] functions as a **phonetic** in 影 yǐng (film) [203].

Which component comes first?
Left 冫 then right 京.

Tips on stroke order
Centre strokes are written before outside strokes.

Practise writing the character.

151

157

快 kuài
fast

Character information

This character combines the **heart radical** 忄 to indicate meaning, with the **phonetic** 夬 guài (decisive) to indicate sound.

Examples

快餐 kuàicān fast food
快乐 kuàilè happy

More about radicals

You can read about the **heart radical** 忄 by turning back to character [5].

Good to know!

You say 祝你生日快乐 zhù nǐ shēngrì kuàilè to wish someone a **happy birthday**.

Which component comes first?

Left 忄 then right 夬.

Tips on stroke order

Left falling strokes are written before right falling strokes.

● ●

Practise writing the character.

158

筷 kuài
chopsticks

Character information

This character combines the **bamboo radical** ⺮ to indicate meaning, with the **phonetic** 快 kuài (fast) to indicate sound.

Examples

筷子 kuàizi chopsticks
一副筷子 yī fù kuàizi a pair of chopsticks

More about radicals

Associated with objects made from **bamboo**, the **bamboo radical** ⺮ is modified from 竹 zhú (which itself looks like **stalks of bamboo**). It appears in 笔 bǐ (pen) and 篮 lán (basket).

Good to know!

副 fù is a **measure word** used for sets or pairs of things, such as 一副手套 yī fù shǒutào (a pair of gloves) and 一副眼镜 yī fù yǎnjìng (a pair of glasses).

Which component comes first?

Upper ⺮ then lower (⺮ then 夬).

Practise writing the character.

ノ	⺮	⺮	⺮	竻	竻	竻	竻	笁	筲	筶	筷	筷

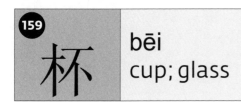

159

杯

bēi
cup; glass

Character information

This character combines the **wood radical** 木 mù to indicate meaning, with the phonetic 不 bù (no) to indicate sound.

Examples

酒杯 jiǔbēi wine glass

世界杯 Shìjièbēi World Cup

两杯水 liǎng bēi shuǐ two glasses of water

More about radicals

You can read about the **wood radical** 木 mù by turning back to character [77].

Which component comes first?

Left 木 then right 不.

Practise writing the character.

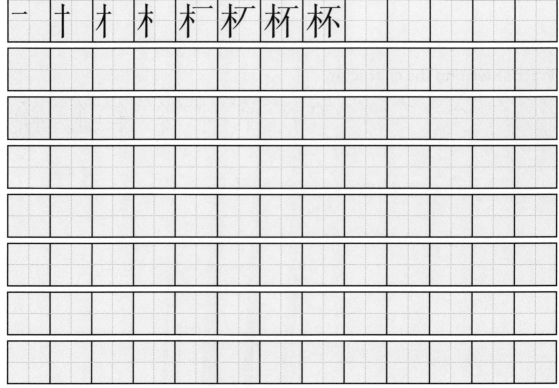

一 十 才 木 朩 杯 杯 杯

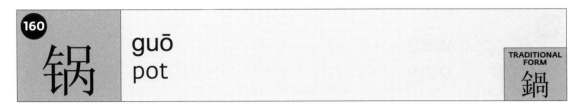

160

锅

guō
pot

TRADITIONAL FORM

鍋

Character information

This character combines the **metal radical** 钅 to indicate meaning, with the **phonetic** 呙 guō (family name) to indicate sound.

Examples

炒菜锅 chǎocàiguō wok
火锅 huǒguō hotpot

More about radicals

You can read about the **metal radical** 钅 by turning back to character [40].

Which component comes first?

Left 钅 then right (口 then 内).

Tips on stroke order

Enclosing strokes are written before enclosed strokes.

• •

Practise writing the character.

| ノ | ᅡ | ᅣ | ᄼ | 钅 | 钔 | 钌 | 铝 | 铝 | 锅 | 锅 | 锅 | | |

161

碗

wǎn
bowl

Character information

This character combines the **stone radical** 石 shí to indicate meaning, with the **phonetic** 宛 wǎn (bent) to indicate sound.

Example

一碗米饭 yī wǎn mǐfàn a bowl of rice

More about radicals

The **stone radical** also appears in 硬 yìng (hard) [99].

Which component comes first?

Left 石 then right 宛.

Practise writing the character.

| 一 | 丆 | 丆 | 石 | 石 | 石`| 石`| 矿 | 矿 | 矿 | 砀 | 碗 | | |

162

员

yuán
employee

Character information

This character represents **talking** 口 kǒu about **business** 贝 bèi (shell, an old form of currency).

Examples

员工 yuángōng staff
成员 chéngyuán member
服务员 fúwùyuán waiter

More about radicals

You can read about the **mouth radical** 口 kǒu by turning back to character [3].

More about phonetics

员 yuán also functions as a **phonetic** in 圆 yuán (round).

Which component comes first?

Upper 口 then lower 贝.

Tips on stroke order

Enclosing strokes are written before enclosed strokes.

Practise writing the character.

163 住 zhù
to live

Character information

This character combines the **human radical** 亻 to indicate meaning, with the **phonetic** 主 zhǔ (host).

Examples

住宾馆 zhù bīnguǎn to stay at a hotel
住院 zhùyuàn to be hospitalized

More about radicals

You can read about the **human radical** 亻 by turning back to character [1].

Which component comes first?

Left 亻 then right 主.

Tips on stroke order

Bottom horizontal strokes are written last.

Practise writing the character.

164

间 jiān
room

間

Character information
This character represents a **door** (门 mén) and **sun** (日 rì).

Examples
房间 fángjiān room
洗手间 xǐshǒujiān toilet

More about radicals
The **gate radical** 门 mén looks like a **door**.

More about phonetics
门 mén also functions as a **phonetic** in characters such as 问 wèn (to ask) [234], 们 men (indicator of plural pronoun), 闷 mēn (stuffy), and 闻 wén (to smell).

Good to know!
洗手间 xǐshǒujiān (toilet) literally means **room for washing hands**.

Which component comes first?
Outer 门 then inner 日.

Tips on stroke order
Enclosing strokes are written before enclosed strokes.

Be careful!
Be careful not to confuse it with 问 wèn [234].

Practise writing the character.

165

房

fáng
house; room

Character information
This character combines 户 hù (household) to indicate meaning with the **radical-phonetic** 方 fāng (square) to indicate sound.

Examples
房子 fángzi house
房间 fángjiān room
书房 shūfáng study

More about radicals
The **square radical** 方 fāng also appears in 旅 lǚ (to travel) [90].

More about phonetics
方 fāng also functions as a **phonetic** in characters such as 访 fǎng (to visit) and 放 fàng (to let go).

Which component comes first?
Upper 户 then lower 方.

Practise writing the character.

丶	丶	乛	户	户	户	户	房					

166

chuáng
bed

Character information
This character represents **wood** (木 mù) under **shelter** (广 guǎng).

Examples
床单 chuángdān bedsheet
单人床 dānrén chuáng single bed
上床 shàngchuáng to go to bed

More about radicals
You can read about the **shelter radical** 广 guǎng by turning back to character [122].

Which component comes first?
Upper 广 then lower 木.

Tips on stroke order
Centre strokes are written before outside strokes.

Practise writing the character.

丶	亠	广	庐	庄	庄	床								

Weather

The weather is a good topic for small-talk at the start of a conversation, so you will be able to practise the words in this section almost every time you get into a taxi in China! The rain radical, introduced here, also appears in some other weather-related words, such as *snow* and *fog*. It is a good example of the principle that some radicals can help you work out, roughly, the meaning of a character you don't know.

In this section, you will learn how to write the following characters, and be introduced to the following radicals:

No.	Chinese	Pinyin	English	Radical introductions
167	气	qì	gas; air	The air radical 气
168	风	fēng	wind	
169	云	yún	cloud	
170	晴	qíng	sunny	
171	冷	lěng	cold	
172	热	rè	heat; hot	
173	度	dù	degree	
174	雨	yǔ	rain	The rain radical 雨
175	雪	xuě	snow	
176	雾	wù	fog	

167

气 qì
gas; air

TRADITIONAL FORM
氣

Character information
This character looks like **moving air**.

Examples
气功 qìgōng *qigong*
气候 qìhòu climate
天气 tiānqì weather

More about radicals
The **air radical** 气 qì is associated with gases. It appears in characters with meanings that relate to gases, such as 氧 yǎng (oxygen).

Good to know!
气功 qìgōng is an ancient Chinese system of postures, breathing exercises and meditations to improve ones 气 qì or **body's energy flow**.

Practise writing the character.

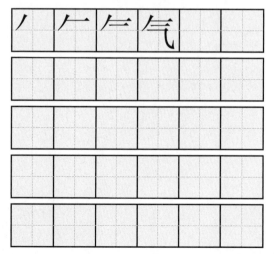

168

风 fēng
wind

TRADITIONAL FORM
風

Examples
风景 fēngjǐng scenery
刮风 guāfēng windy

Tips on stroke order
Enclosing strokes are written before enclosed strokes.

Be careful!
Be careful not to confuse it with 网 wǎng [108].

Practise writing the character.

169

云 yún
cloud

TRADITIONAL
FORM

雲

Character information

This character combines the **two radical** 二 èr with 厶 sī (private).

Examples

云南 Yúnnán Yunnan Province
多云 duōyún cloudy

More about radicals

You can read about the **two radical** 二 èr by turning back to character [27].

Lost in simplification

The traditional form contains the **rain radical** 雨 yǔ, which appears in the simplified form of some other weather-related characters, such as 雪 xuě (snow) [175].

Practise writing the character.

170

晴 qíng
sunny

Character information

This character combines the **sun radical** 日 rì to indicate meaning, with the **phonetic** 青 qīng (blue; green) to indicate sound.

Example

晴天 qíngtiān sunny

More about radicals

You can read about the **sun radical** 日 rì by turning back to character [37].

More about phonetics

青 qīng functions as a **phonetic** in other characters such as 请 qǐng (to ask) [246] and 静 jìng (quiet).

Which component comes first?

Left 日 then right 青.

Be careful!

Be careful not to confuse it with 请 qǐng (to ask) [246].

• •

Practise writing the character.

171

冷 lěng
cold

Character information

This character combines the **ice radical** 冫 to indicate meaning, with the **phonetic** 令 lìng (to command) to indicate sound.

Examples

冷冻 lěngdòng to freeze
冷饮 lěngyǐn cold drink

More about radicals

You can read about the **ice radical** 冫 by turning back to character [156].

More about phonetics

令 lìng functions as a **phonetic** in other characters such as 零 líng (zero) and 邻 lín (neigbour).

Which component comes first?

Left 冫 then right 令.

Be careful!

Be careful not to confuse the **phonetic** 令 lìng with 今 jīn (today) [52].

Practise writing the character.

172

热

rè
heat; hot

TRADITIONAL FORM

熱

Character information

This character combines the **fire radical** ⺗
to indicate meaning, with 执 zhí (to hold in
the hand).

Examples

热闹 rènào lively
热心 rèxīn warm-hearted
发热 fārè to have a fever

More about radicals

You can read about the **fire radical** ⺗
by turning forward to character [220].

Which component comes first?

Upper (扌 then 丸) then lower ⺗.

Practise writing the character.

一	亅	扌	扚	执	执	执	热	热	热			

173

度 dù
degree

Character information
This character combines the **shelter radical** 广 guǎng with 廿 niàn (twenty) and 又 yòu (again).

Examples
度假 dùjià to go on holiday
态度 tàidu attitude
温度 wēndù temperature

More about radicals
You can read about the **shelter radical** 广 guǎng by turning back to character [122].

More about phonetics
度 dù functions as a **phonetic** in 渡 dù (to cross a river or the sea). Note the water radical 氵 to indicate meaning.

Which component comes first?
Outer 广 then inner (廿 then 又).

Tips on stroke order
Enclosing strokes are written before enclosed strokes.

Practise writing the character.

丶	亠	广	庐	庐	庐	庶	庹	度				

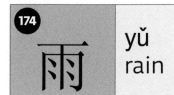

174

雨

yǔ
rain

Character information
This character looks like **drops of water falling from the sky**.

Examples
雨伞 yǔsǎn umbrella
下雨 xiàyǔ to rain

More about radicals
The **rain radical** 雨 yǔ is associated with the **weather**. It appears in 雪 xuě (snow) [175] and 雾 wù (fog) [176].

Good to know!
下大雨 xiàdàyǔ means **to rain heavily** (literally 'big rain').

Tips on stroke order
Enclosing strokes are written before enclosed strokes.

Be careful!
Be careful not to confuse it with 丽 lì (beautiful).

● ●

Practise writing the character.

175

xuě
snow

Character information
This character represents **rain** (雨 yǔ) that can be **swept away** (彗 huì, abbreviated to 彐).

Examples
下雪 xiàxuě to snow
雪花 xuěhuā snowflake

More about radicals
You can read about the **rain radical** 雨 yǔ by turning back to character [174].

Good to know!
雪花 xuěhuā (snowflake) literally means **snow flower**.

Which component comes first?
Upper 雨 then lower 彐.

Tips on stroke order
Enclosing strokes are written before enclosed strokes.

* *

Practise writing the character.

176

wù
fog

TRADITIONAL FORM
霧

Character information

This character combines the **rain radical** 雨 yǔ to indicate the meaning, with the **phonetic** 务 wù (affairs; business).

Example

雾气 wùqì fog

More about radicals

You can read about the **rain radical** 雨 yǔ by turning back to character [174].

Which component comes first?

Upper 雨 then lower (夂 then 力).

● ●

Practise writing the character.

Culture

This section introduces characters and words that relate to the riches of Chinese culture, religion and education. You will find words that originated in the ancient era (martial arts, Tang poetry and Beijing opera), and ones that have arisen in modern times (films, concerts and karaoke).

One very common radical introduced here is the speech radical, which indicates quite reliably that a character has something to do with talking and language.

In this section, you will learn how to write the following characters, and be introduced to the following radicals:

No.	Chinese	Pinyin	English	Radical introductions
177	书	shū	book	
178	文	wén	culture	The script radical 文
179	孔	kǒng	opening; family name	
180	古	gǔ	ancient	
181	术	shù	art; skill	
182	汉	hàn	the Han people	
183	玉	yù	jade	
184	节	jié	joint; festival	
185	乐	yuè; lè	music; happy	
186	龙	lóng	dragon	The dragon radical 龙
187	写	xiě	to write	The cover radical 冖
188	字	zì	character	
189	寺	sì	temple; mosque	
190	灯	dēng	light	
191	纸	zhǐ	paper	The silk radical 纟
192	学	xué	to study	
193	画	huà	to paint	The container radical 凵
194	诗	shī	poetry	The speech radical 讠
195	宫	gōng	palace	
196	语	yǔ	language	
197	剧	jù	drama	
198	教	jiào	to teach	The rap radical 攵
199	春	chūn	spring	
200	唱	chàng	to sing	
201	歌	gē	song	The lack radical 欠
202	演	yǎn	to perform	
203	影	yǐng	shadow; film	The bristle radical 彡

177 书 shū book

TRADITIONAL FORM 書

Examples
书店 shūdiàn bookshop
读书 dúshū to study; attend school
教书 jiāoshū to be a teacher
看书 kànshū to read

More about radicals
You can read about the **second radical** フ by turning back to character [103].

Tips on stroke order
Minor strokes are written last.

. .

Practise writing the character.

178 文 wén culture

Character information
This character originally looked like a man with a **tattooed chest**.

Examples
文化 wénhuà culture
文明 wénmíng civilization; civilized
中文 Zhōngwén Chinese language

More about phonetics
文 wén also functions as a **phonetic** in words like 纹身 wénshēn (tattoo) and 蚊子 wénzi (mosquito).

Good to know!
中文 Zhōngwén refers to **written Chinese**, whereas 汉语 Hànyǔ tends to refer to **spoken Chinese**. 语文 yǔwén refers to both spoken and written language.

Be careful!
Be careful not to confuse it with 女 nǚ (woman) [2].

. .

Practise writing the character.

179 · kǒng · opening; family name

Character information
This character combines the **second radical** ㄥ with 子 zǐ (child).

Examples
孔子 Kǒngzǐ Confucius
孔雀 kǒngquè peacock

More about radicals
You can read about the **second radical** ㄥ by turning back to character [103].

Good to know!
孔子 Kǒngzǐ **Confucius** (551-479 BC) was a hugely influential thinker. A posthumous compilation of his sayings, 论语 Lúnyǔ The Analects, is China's most important philosophical work and was the key text on which much of the traditional Chinese education system was based.

Practise writing the character.

180 · gǔ · ancient

Character information
This character combines the **cross radical** 十 shí with 口 kǒu (mouth).

Examples
古典音乐 gǔdiǎn yīnyuè classical music
古玩 gǔwán antique; curio

More about radicals
You can read about the **cross radical** 十 shí by turning back to character [35].

More about phonetics
古 gǔ also functions as a **phonetic** in characters such as 故 gù (reason), 姑 gū (aunt) and 苦 kǔ (bitter).

Practise writing the character.

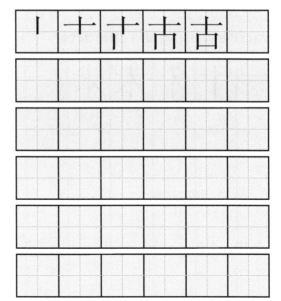

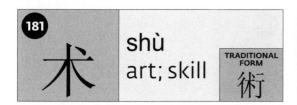

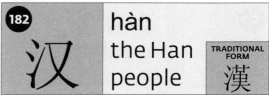

Character information

This character combines the **wood radical** 木 mù with a dot 丶

Examples

技术 jìshù technology
艺术 yìshù art
魔术 móshù magic
武术 wǔshù martial arts

More about radicals

You can read about the **wood radical** 木 mù by turning back to character [77].

Tips on stroke order

Horizontal strokes are written before the vertical strokes. Centre strokes are written before outside strokes. Minor strokes are written last.

Practise writing the character.

Character information

This character combines the **water radical** 氵 with 又 yóu (again).

Examples

汉语 Hànyǔ Chinese language
汉字 Hànzì Chinese characters
汉族 Hànzú the Han nationality

More about radicals

You can read about the **water radical** 氵 by turning back to character [130].

Good to know!

There are around 47,000 Chinese characters. Studies have concluded that only around 3,000 to 4,000 characters are necessary for full literacy in Chinese.

Which component comes first?

Left 氵 then right 又.

Practise writing the character.

Character information
This character represents **jewels** (丶) carried by a **king** (王 wáng).

Example
玉米 yùmǐ corn; maize

More about radicals
You can read about the **king radical** 王 **wáng** by turning back to character [6].

Tips on stroke order
Horizontal strokes are written before the vertical strokes. Minor strokes are written last.

● ●
Practise writing the character.

Character information
The traditional form is a better guide to the original meaning as it contains the **bamboo radical** ⺮ indicating **joint**.

Examples
节目 jiémù programme (e.g. on television)
节日 jiérì traditional holiday
一节课 yī jié kè one lesson

More about radicals
You can read about the **grass radical** ⺿ by turning back to character [134].

Which component comes first?
Upper ⺿ then lower.

● ●
Practise writing the character.

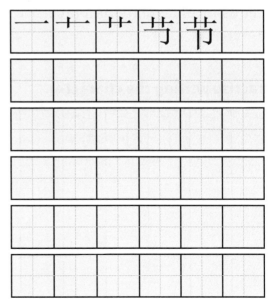

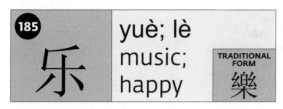

185

乐

yuè; lè
music;
happy

TRADITIONAL
FORM

樂

Character information

The traditional form respresents **music**, with **strings** (纟) and **wood** (木 mù).

Examples

音乐 yīnyuè music
快乐 kuàilè happy
乐观 lèguān optimistic

More about radicals

You can read about the **slash radical** 丿 by turning back to character [11].

Good to know!

Notice that this character has different pronunciations depending on where the character means music (yuè) or happy (lè).

Tips on stroke order

Centre strokes are written before outside strokes.

186

龙

lóng
dragon

TRADITIONAL
FORM

龍

Character information

This character originally looked like a **dragon**. The traditional form seems to show **scaly wings**.

Examples

龙船 lóngchuán dragon boat
龙头 lóngtóu tap
龙舞 lóngwǔ dragon dance

More about phonetics

龙 lóng also functions as a **phonetic** in some characters such as 聋 lóng (deaf) and 笼 lóng (basket, appears in lantern [190]).

Good to know!

In China **dragons** are a symbol of good luck and power, and the dragon is one of the Chinese zodiac signs. 2012 is the year of the dragon, and the one after that will be in 2024.

• •

Practise writing the character.

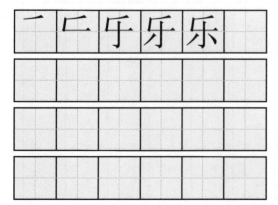

• •

Practise writing the character.

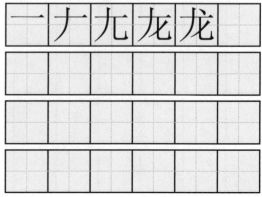

187 写 xiě to write

TRADITIONAL FORM 寫

Character information

This character combines the **cover radical** ⼧ with 与 yǔ (and).

Examples

写字 xiězì to write characters
写作 xiězuò to write
描写 miáoxiě to describe

More about radicals

The **cover radical** ⼧ is quite rare. An example of another character that features it is 军 jūn (army).

Which component comes first?

Upper ⼧ then lower 与.

Practise writing the character.

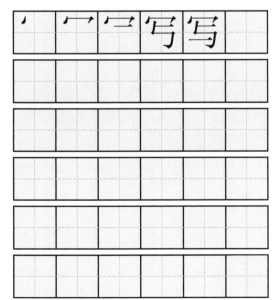

188 字 zì character

Character information

This character combines the **roof radical** ⼧ to indicate meaning, with the **phonetic** 子 zǐ (child) to indicate sound.

Examples

字典 zìdiǎn dictionary
字幕 zìmù caption; subtitle
汉字 Hànzì Chinese characters

More about radicals

You can read about the **roof radical** ⼧ by turning back to character [25].

Be careful!

Be careful not to confuse it with 学 xuě (to study) [192].

Practise writing the character.

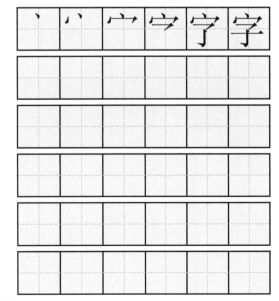

189

寺

sì
temple; mosque

Character infomation
This character combines the **earth radical** 土 tǔ with 寸 cùn (inch). Here 寸 indicates **making laws**.

Examples
寺庙 sìmiào temple
清真寺 qīngzhēnsì mosque

More about radicals
You can read about the **earth radical** 土 tǔ by turning back to character [68].

More about phonetics
寺 sì functions as a **phonetic** in 诗 shī (poetry) [194].

Good to know!
In the word for **mosque**, 清真 qīngzhēn literally translates as **clean and true**, indicating purity. Muslim restaurants, very common in western China, put this on a sign above the door to show that they are halal, and therefore do not serve pork or alcohol.

Which component comes first?
Upper 土 then lower 寸.

Tips on stroke order
Minor strokes are written last.

Practise writing the character.

190

灯

dēng
light

TRADITIONAL FORM

燈

Character information

This character combines the **fire radical** 火 huǒ to indicate meaning, with the **phonetic** 丁 dīng (family name) to indicate sound.

Examples

灯笼 dēnglóng lantern
红绿灯 hónglǜdēng traffic lights
路灯 lùdēng street light

More about radicals

You can read about the **fire radical** 火 by turning forward to character [220].

Lost in simplification

The traditional form uses the **phonetic** 登 dēng (to go up) [106], which is the exact sound required. The **phonetic** in the simplified form (丁 dīng), while similar, has sacrifices sound for convenience.

Good to know!

Red lanterns are a traditional Chinese symbol. You will see these displayed particularly during Chinese New Year. You can read about the **Lantern Festival** by turning back to character [118].

Which component comes first?

Left 火 then right 丁.

Practise writing the character.

191

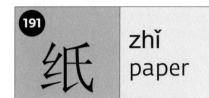
纸

zhǐ
paper

紙

Character information

This character combines the **silk radical** 纟 to indicate meaning, with the **phonetic** 氏 shì (clan) to indicate sound.

Examples

纸币 zhǐbì banknote
报纸 bàozhǐ newspaper
一张纸 yī zhāng zhǐ a sheet of paper

More about radicals

The **silk radical** 纟 looks like twisted threads. It appears in 线 xiàn (thread), 结 jié (knot), as well as in the colours 红 hóng (red) [205] and 绿 lǜ (green) [206].

Which component comes first?

Left 纟 then right 氏.

Practise writing the character.

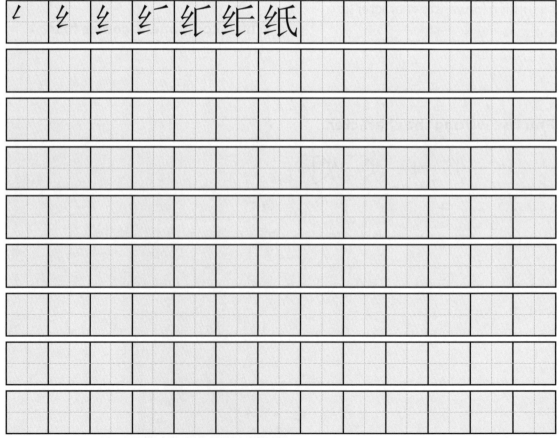

192

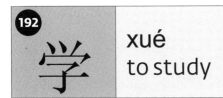

学

xué
to study

學

Character information

This character represents learning as **hands** (⺍) on the **head** (冖) of a **child** (子 zǐ).

Examples

学生 xuéshēng student
学习 xuéxí to study
学校 xuéxiào school

More about radicals

The **dot radical** 丶 is not associated with any meaning. It appears in 半 bàn (half) [42].

Which component comes first?

Upper (⺍ then 冖) then lower 子.

Be careful!

Be careful not to confuse it with 字 zì (character) [188].

Practise writing the character.

193

画

huà
to paint

TRADITIONAL FORM

畫

Character information

This character represents **painted lines** (一 and 凵) around a **field** (田 tián).

Examples

画画 huàhuà to paint a picture
画家 huàjiā painter
画展 huàzhǎn art exhibition

More about radicals

The **container radical** 凵 is associated with **containers**. It appears in 函 hán (case) and 出 chū (to go out) [227].

Which component comes first?

Upper 一, inner 田, then outer 凵.

Tips on stroke order

Bottom enclosing strokes are written after enclosed strokes.

Practise writing the character.

194 诗 shī
poetry

TRADITIONAL FORM
詩

Character information
This character combines the **speech radical** 讠 to indicate meaning, with the **phonetic** 寺 sì (temple; mosque) to indicate sound.

Examples
诗人 shīrén poet
唐诗 Tángshī Tang dynasty (618-905) poetry

More about radicals
Associated with talking and language, the **speech radical** 讠 is modified from 言 yán. It appears in 语 yǔ (language) [196], 说 shuō (to say) [243], and 请 qǐng (to ask) [246].

More about phonetics
You can read about the **phonetic** 寺 sì by turning back to character [189].

Lost in simplification
Notice how the traditional form uses the unmodified **speech radical** 言 yán.

Good to know!
The classic poetry anthology 唐诗三百首 Tángshī Sānbǎi Shǒu **Three Hundred Tang Poems** is studied by most Chinese schoolchildren.

Which component comes first?
Left 讠 then right 寺.

Tips on stroke order
Minor strokes are written last.

Practise writing the character.

195

宫

gōng
palace

Character information
This character represents a building with a **roof** (宀) and **many rooms** (吕 lǚ).

Examples
故宫 gùgōng the Forbidden City
王宫 wánggōng royal palace

More about radicals
You can read about the **roof radical** 宀 by turning back to character [25].

Good to know!
As the largest collection of ancient wooden structures in the world,

故宫 gùgōng (**the Forbidden City**) formed the imperial palaces of the Ming (1368-1644) and Qing (1644-1911) dynasties. It is located at what was once the exact centre of the old city of Beijing, just to the north of Tiananmen Square. It is now a major tourist attraction.

Which component comes first?
Upper 宀 then lower 吕.

Tips on stroke order
Left vertical strokes are written before top horizontal strokes. Bottom horizontal strokes are written last.

Practise writing the character.

196 语 yǔ
language

TRADITIONAL FORM

語

Character information

This character combines the **speech radical** 讠 to indicate meaning, with the **phonetic** 吾 wú (me) to indicate sound.

Examples

语言 yǔyán language
手语 shǒuyǔ sign language
英语 Yīngyǔ English (language)

More about radicals

You can read about the **speech radical** 讠 by turning back to character [194].

More about phonetics

Notice how the **phonetic** 吾 wú itself contains 五 wǔ (five) [30], while 口 kǒu (mouth) [3] further contributes to the meaning.

Good to know!

Sign language (手语 shǒuyǔ) literally means hand language.

Which component comes first?

Left 讠 then right (五 then 口).

Tips on stroke order

Bottom horizontal strokes are written last.

Practise writing the character.

197

剧

jù
drama

劇

Character information

This character combines the **knife radical** 刂 with the **phonetic** 居 jū (to live) to indicate sound.

Examples

剧场　jùchǎng　theatre
电视剧　diànshìjù　TV drama series
京剧　jīngjù　Beijing opera

More about radicals

You can read about the **knife radical** 刂 by turning back to character [61].

Good to know!

京剧 jīngjù is a form of **Chinese traditional opera** which enjoys a history of over two hundred years, and is regarded as one of the most important Chinese cultural heritages. The performances combine acting, music, dialogue, dancing and acrobatics.

Which component comes first?

Left 居 then right 刂.

Practise writing the character.

198

教

jiào
to teach

Character information

This character combines the **rap radical** 攵 suī to indicate meaning, with the **phonetic** 孝 xiào (filial piety) to indicate sound.

Examples

教师 jiàoshī teacher
教育 jiàoyù education
佛教 Fójiào Buddhism

More about radicals

The **rap radical** 攵 suī looks like a hand holding a stick. It appears in 收 shōu (to receive) and 救 jiù (to rescue).

Good to know!

You can also remember this character by associating learning with young people learning from and respecting their (stick-carrying) elders.

Which component comes first?

Left 孝 then right 攵.

Practise writing the character.

199

chūn
spring

Character information
This character represents **plants** (夫) growing in the **sun** (日 rì).

Examples
春节 Chūn Jié Chinese New Year
春卷 chūnjuǎn spring roll
春天 chūntiān spring

More about radicals
You can read about the **sun radical** 日 rì by turning back to character [37].

Good to know!
春节 Chūn Jié **Chinese New Year**, or **Spring Festival**, is the most important festival of the year and falls on the first day of the lunar calendar. Traditionally families gather together and children receive money in red envelopes, and in some parts of China everyone helps make and eat a festival feast. When greeting people during this festival it is traditional to wish them wealth and happiness, by saying 恭喜发财 gōngxǐ fācái.

Which component comes first?
Upper 夫 then lower 日.

Practise writing the character.

200

唱

chàng
to sing

Character information

This character combines the **mouth radical** 口 kǒu to indicate meaning, with the **phonetic** 昌 chāng (prosperous) to indicate sound.

Examples

唱歌　chànggē　to sing

唱卡拉OK　chàng kǎlā-OK　to sing karaoke

More about radicals

You can read about the **mouth radical** 口 kǒu by turning back to character [3].

Good to know!

卡拉-OK kǎlā-OK **karaoke** is a very popular pasttime in China. The word is a loan from Japanese. Look out for KTV signs.

Which component comes first?

Left 口 then right 昌.

Tips on stroke order

Notice how the lower sun is wider then the upper one.

● ●

Practise writing the character.

201

歌　gē
song

Character information

This character combines the **yawn radical** 欠 qiàn with the **phonetic** 哥 gē (elder brother) to indicate sound.

Examples

歌词　gēcí　lyrics
歌手　gēshǒu　singer
唱歌　chànggē　to sing

More about radicals

The **lack radical** 欠 qiàn is associated with **exhalation**. It appears in 吹 chuī (to blow) and 哈欠 hāqian (to yawn).

More about phonetics

The **phonetic** 哥 gē has been borrowed from the character for elder brother [18].

Which component comes first?

Left 哥 then right 欠.

Tips on stroke order

Left falling strokes are written before right falling strokes.

Practise writing the character.

一	丆	丌	可	可	可	哥	哥	哥	哥	哥	哥	歌
歌												

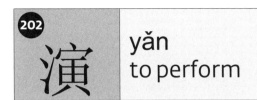

202

演

yǎn
to perform

Character information

This character combines the **water radical** 氵 to indicate meaning, with the **phonetic** 寅 yín (to respect) to indicate sound.

Examples

演唱会 yǎnchànghuì concert
演员 yǎnyuán performer
表演 biǎoyǎn performance

More about radicals

演 yǎn also means **evolve**, which explains why the water radical appears. You can read about the **water radical** 氵 by turning back to character [130].

Which component comes first?

Left 氵 then right 寅.

Practise writing the character.

193

203

影

yǐng
shadow; film

Character information

This character combines the **bristle radical** 彡 to indicate meaning, with the **phonetic** 景 jǐng (scenery) to indicate sound.

Examples

影响 yǐngxiǎng to affect
电影 diànyǐng film

More about radicals

The **bristle radical** 彡 is associated with hair or rays of light. It appears in 彩 cǎi (colour) and 须 xū (beard).

More about phonetics

The **phonetic** 景 jǐng gets its own sound from 京 jīng (capital) [71], which also appears as a phonetic in 凉 liáng (cool) [156].

Which component comes first?

Left 景 then right 彡.

Practise writing the character.

丨	冂	冂	日	뎌	뎌	昌	景	景	景	景	景	影
影	影											

Colours

The characters selected for the colours section were chosen because of the wide variety of words that feature these characters. You will find verbs (*to understand*), place names (*Heilongjiang Province* and the *Yellow River*), and a few items of food and drink (*boiled water* and *cucumber*).

It is always interesting to try to work out how Chinese words are created by looking at the underlying meanings of the characters. Occasionally, this offers a fascinating glimpse of how the Chinese view the world with different eyes from Westerners. For instance, if you wish to order some black tea in a Chinese teahouse, you need to ask for 'red' tea.

In this section, you will learn how to write the following characters, and be introduced to the following radicals:

No.	Chinese	Pinyin	English	Radical introductions
204	白	bái	white	The white radical 白
205	红	hóng	red	
206	绿	lǜ	green	
207	黄	huáng	yellow	
208	黑	hēi	black; dark	The black radical 黑
209	蓝	lán	blue	

204

白

bái
white

Character information
This character looks like **a burning candle**. It contains 日 rì (sun).

Examples
白色　báisè　white
白开水　bái kāishuǐ　plain boiled water
白天　báitiān　daytime
明白　míngbai　to understand

More about radicals
The **white radical** 白 bái is associated with **clarity and light**. It appears in 泉 quán (fresh water spring).

Good to know!
Visitors to China soon discover that 白开水 bái kāishuǐ **fresh boiled water** is a staple drink. Boiled water is so important that almost all Chinese people carry around a small flask, which they can refill - at no cost - in many places, such as schools, offices, or in train stations.

Which component comes first?
Upper dash then lower 日.

Tips on stroke order
Left vertical strokes are written before top horizontal strokes. Bottom horizontal strokes are written last.

Be careful!
Be careful not to confuse it with 日 rì (sun) [37].

Practise writing the character.

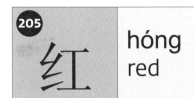

205
红
hóng
red

Character information
This character combines the **silk radical** 纟 to indicate meaning, with the **phonetic** 工 gōng (work) to indicate sound.

Examples
红色 hóngsè red
红茶 hóngchá black tea
红酒 hóngjiǔ red wine
红烧肉 hóngshāoròu braised meat in soy sauce

More about radicals
You can read about the **silk radical** 纟 by turning back to character [191].

More about phonetics
You can read about the **phonetic** 工 gōng by turning back to character [78].

Good to know!
Red is a lucky colour in China, worn by brides at weddings, and gifted in the form of red envelopes full of money on the Chinese New Year.

Which component comes first?
Left 纟 then right 工.

Tips on stroke order
Bottom horizontal strokes are written last.

Be careful!
Be careful not to confuse it with 江 jiāng (river) [78].

Practise writing the character.

colours

Character information
This character combines the **silk radical**
纟 to indicate meaning, with the **phonetic**
录 lǜ (copy) to indicate sound.

Examples
绿色 lǜsè green
绿茶 lǜchá green tea
绿豆 lǜdòu mung bean

More about radicals
You can read about the **silk radical** 纟
by turning back to character [191].

Which component comes first?
Left 纟 then right 录.

Practise writing the character.

| 乡 | 纟 | 纟 | 纟 | 纩 | 纩 | 绉 | 绿 | 绿 | 绿 | | |

207

黄

huáng
yellow

TRADITIONAL FORM

黃

Character information

This character has evolved considerably over time, but it might be helpful to think that **yellow** is the colour of the wheat-growing **fields** (田 tián) in northern China.

Examples

黄色 huángsè yellow
黄瓜 huángguā cucumber
黄河 Huánghé the Yellow River
黄油 huángyóu butter

More about radicals

You can read about the **divide radical** 八 bā by turning back to character [33].

Good to know!

黄油 huángyóu **butter** literally means **yellow oil**.

Tips on stroke order

Top to bottom.

Practise writing the character.

| 一 | 十 | 艹 | 苂 | 芇 | 芐 | 昔 | 黄 | 苗 | 黄 | 黄 | | |

208

黑

hēi
black; dark

Character information
This character represents a **window** that has been smudged by **the smoke of a fire** (灬).

Examples
黑色 hēisè black
黑板 hēibǎn blackboard
黑龙江 Hēilóngjiāng Heilongjiang Province

More about radicals
The **black radical** 黑 hēi is associated with **black** or **darkened** objects. It appears in 墨 mò (ink).

Good to know!
The name of Heilongjiang Province, in northeast China, translates as **black dragon river**.

Which component comes first?
Upper then lower 灬.

Tips on stroke order
Enclosing strokes are written before enclosed strokes.

Practise writing the character.

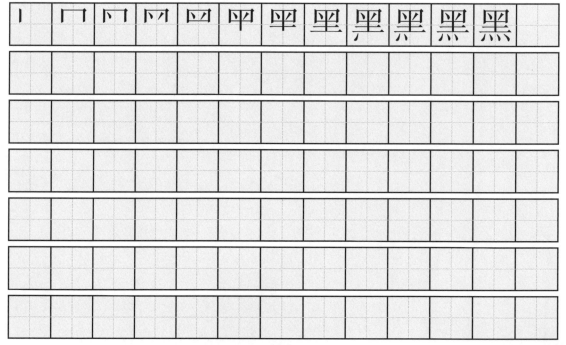

Character information

This character combines the **grass radical** ⁺⁺ to indicate meaning, with the **phonetic** 监 jiān (to supervise) to indicate sound.

Examples

蓝色 lánsè blue
蓝天 lántiān blue sky

More about radicals

You can read about the **grass radical** ⁺⁺ by turning back to character [134].

Which component comes first?

Upper ⁺⁺ then lower 监.

Tips on stroke order

Bottom horizontal strokes are written last.

Practise writing the character.

Basics

In this final section, we have gathered together a wide selection of common Chinese words that do not fit very comfortably in the previous twelve topics. These are the kinds of characters that you will see everyday on signs and notices in your hotel, in train stations, or as you walk down the street. You will also learn how to write some common verbs, nouns and adjectives, which are frequently used in daily conversation.

In this section, you will learn how to write the following characters, and be introduced to the following radicals:

No.	Chinese	Pinyin	English	Radical introductions
210	不	bù	no	
211	太	tài	too	
212	再	zài	again	
213	大	dà	big	The big radical 大
214	小	xiǎo	small	The small radical 小
215	好	hǎo	good	
216	老	lǎo	old	The old radical 老
217	美	měi	beautiful	
218	疼	téng	sore; painful	The sickness radical 疒
219	新	xīn	new	
220	火	huǒ	fire	The fire radical 火(灬)
221	电	diàn	electricity	The field radical 田
222	药	yào	medicine	
223	球	qiú	ball	
224	入	rù	to enter	
225	开	kāi	to open	
226	见	jiàn	to see	The see radical 见
227	出	chū	to go out	
228	叫	jiào	to shout; to call	
229	打	dǎ	to hit	
230	生	shēng	to give birth	
231	用	yòng	to use	The use radical 用
232	对	duì	to face; correct	The right hand radical 又
233	关	guān	to close	
234	问	wèn	to ask	
235	欢	huān	to welcome	
236	听	tīng	to listen to	
237	有	yǒu	to have; to exist	
238	没	méi	to not have; not	
239	拉	lā	to pull	
240	是	shì	to be; yes	
241	看	kàn	to look at	
242	要	yào	to need; to want	
243	说	shuō	to say	
244	爱	ài	to love	the claw radical 爪(爫)
245	能	néng	to be able	
246	请	qǐng	to ask; to invite	
247	推	tuī	to push	
248	谢	xiè	to thank	
249	想	xiǎng	to think; to feel; to miss	
250	禁	jìn	to prohibit	

210 不 bù
no

Character information

This character looks like a **seed growing under the ground** (一), or a **bird flying towards the sky** (一).

Examples

不错 búcuò correct
不少 bùshǎo a lot of
不要 búyào do not need

More about radicals

You can read about the **one** radical 一 yī by turning back to character [26].

Good to know!

不 bù is the fourth tone unless it is followed by another fourth tone syllable, in which case it is usually pronounced as a second tone, for example 不要 búyào.

Be careful!

Be careful not to confuse it with 下 xià (under) [55].

• •

Practise writing the character.

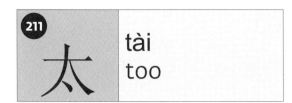

Character information

This character represents the idea **more than big** (i.e. too) by using the **big radical** 大 dà with a **dot** (丶) for emphasis.

Examples

太长 tài cháng too long
太极拳 tàijíquán t'ai chi
太太 tàitai wife
太阳 tàiyáng sun

More about radicals

You can read about the **big radical** 大 dà by turning forward to character [213].

Be careful!

Be careful not to confuse it with 大 dà (big) [213].

Practise writing the character.

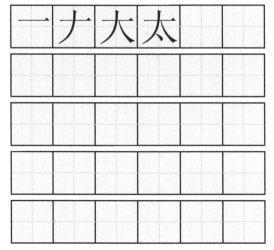

Character information

This character contains the **one radical** 一 yī and 冂 (open country).

Example

再见 zàijiàn goodbye

More about radicals

You can read about the **one** radical 一 yī by turning back to character [26].

Good to know!

Say 你再说一遍 Nǐ zài shuō yī biàn when you would like someone to **say that again**.

Practise writing the character.

213 大 dà big

Character information
This character looks like a **person with outstretched arms**.

Examples
大家 dàjiā everybody
大小 dàxiǎo size
大学 dàxué university

More about radicals
The **big radical** 大 dà is associated with **largeness**. It appears in 太 tài (too) [211], 美 měi (beautiful) [217], and 夸 kuā (to exaggerate).

Be careful!
Don't confuse it with 太 tài (too) [211].

Practise writing the character.

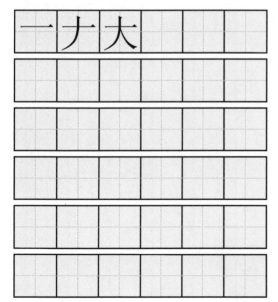

214 小 xiǎo small

Character information
This character represents **division** (八 bā) by a **tool** (亅).

Examples
小吃 xiǎochī snack
小说 xiǎoshuō novel
小心 xiǎoxīn to be careful

More about radicals
The **small radical** 小 xiǎo is associated with **smallness** or **insignificance**. It appears in 省 shěng (province) [73].

Good to know!
小心 xiǎoxīn **be careful**, seen on many signs in China, literally means **little heart**.

Practise writing the character.

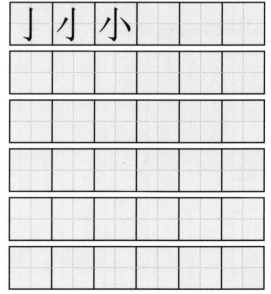

Character information

This character shows that a **woman** (女 nǔ) with a **child** (子 zǐ) is **good**.

Examples

好吃 hǎochī delicious
好久 hǎojiǔ for a long time
好看 hǎokàn nice-looking; a good read
 (book)

More about radicals

You can read about the **woman radical** 女 nǔ by turning back to character [2].

Good to know!

You use 好 hǎo in **greetings**, as in 你好！Nǐhǎo! **Hello!** and 你好吗？ Nǐ hǎo ma? **How are you?**

• •

Practise writing the character.

Character information

This character shows an **old person with a walking stick**.

Examples

老年人 lǎoniánrén the elderly
老板 lǎobǎn boss
老家 lǎojiā hometown
老师 lǎoshī teacher

Good to know!

The term 老外 lǎowài is one of several words for foreigner. It is the informal version of 外国人 wàiguórén and literally translates as **old foreigner**. It is a commonly used term in everyday spoken Chinese to refer to foreigners in general.

• •

Practise writing the character.

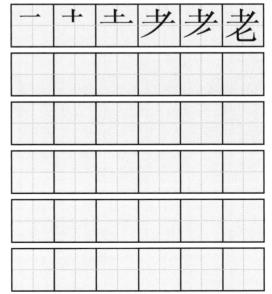

217

美 měi
beautiful

Character information
This character shows that a **fat** (大 dà) **sheep** (羊 yáng) is **beautiful**.

Examples
美国 Měiguó USA
美丽 měilì beautiful
美术 měishù fine arts; painting
美元 měiyuán US dollar

More about radicals
You can read about the **big radical** 大 dà by turning back to character [213].

Which component comes first?
Upper 羊 then lower 大.

● ●

Practise writing the character.

丶	丷	丷	兰	羊	羊	羊	美	美			

218

疼

téng
sore; painful

Character information

This character combines the **sickness radical** 疒 to indicate meaning, with the **phonetic** 冬 dōng (winter) to indicate sound.

Examples

背疼 bèiténg backache
头疼 tóuténg headache
牙疼 yáténg toothache

More about radicals

The **sickness radical** 疒 is associated with **disease**. It appears in 病 bìng (illness), 疗 liáo (to cure) and 瘦 shòu (thin).

Which component comes first?

Outer 疒 then inner 冬.

Tips on stroke order

Minor strokes are written last.

Practise writing the character.

| 丶 | 亠 | 广 | 广 | 疒 | 疒 | 疒 | 疚 | 疼 | 疼 | | | |

219

新

xīn
new

Character information

This character combines the **axe radical** 斤 jīn with the **phonetic** 亲 qīn (parent) to indicate sound.

Examples

新年 xīnnián New Year
新闻 xīnwén news
新鲜 xīnxiān fresh

More about radicals

You can read about the **axe radical** 斤 jīn by turning back to character [119].

Which component comes first?

Left 亲 then right 斤.

Tips on stroke order

Centre strokes are written before outside strokes.

• •

Practise writing the character.

丶	亠	亠	立	立	立	辛	辛	亲	亲	新	新	新

220 火 huǒ fire

Character information
This character looks like the **flames of a fire**.

Examples
火车 huǒchē train
火车站 huǒchēzhàn railway station
发火 fāhuǒ to get angry

More about radicals
Associated with **fire** and **heat**, the **fire radical** 火 (also modified to 灬) appears in characters such as 炒 chǎo (to stir-fry) [135] and 热 rè (hot) [172].

221 电 diàn electricity

TRADITIONAL FORM
電

Examples
电话 diànhuà telephone
电脑 diànnǎo computer
电视 diànshì television
电影 diànyǐng film
电子邮件 diànzǐ yóujiàn email

Lost in simplification
The traditional form represents **lightning** appearing from **rain clouds** (雨 yǔ).

Which component comes first?
Note that it is formed by writing a verticle stroke through 日.

Practise writing the character.

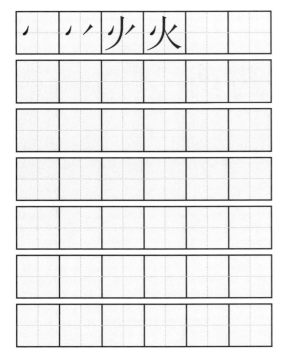

Practise writing the character.

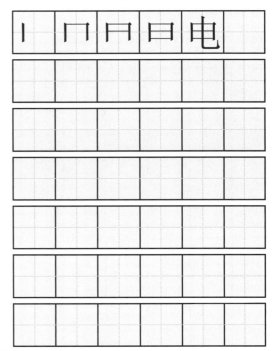

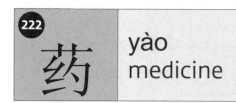

222

yào
medicine

TRADITIONAL FORM

藥

Character information

This character combines the **grass radical** 艹 to indicate meaning, with the **phonetic** 约 yuē (treaty) to indicate sound.

Examples

药店 yàodiàn chemist's
药方 yàofāng prescription
吃药 chīyào to take medicine
中药 Zhōngyào Chinese medicine

More about radicals

You can read about the **grass radical** 艹 by turning back to character [134].

Lost in simplification

The traditional form depicts medicine as **plants** (艸 cǎo) that bring **happiness** (樂 yuè). The simplified form replaces the happiness component, retaining its sound, but losing the original meaning.

Good to know!

There is a long tradition of Chinese medicine, and it is still popular today. However, you can easily get common western drugs in hospitals and chemist's.

Which component comes first?

Upper 艹 then lower (纟 then 勺).

Tips on stroke order

Minor strokes are written last.

Practise writing the character.

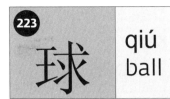

223

球 qiú
ball

Character information

This character combines the **king radical** 王 wáng with the **phonetic** 求 qiú (to request) to indicate sound.

Examples

篮球 lánqiú basketball
乒乓球 pīngpāngqiú table tennis
足球 zúqiú football

More about radicals

You can read about the **king radical** 王 wáng by turning back to character [6].

More about phonetics

求 qiú functions as a **phonetic** in 救 jiù (to rescue).

Which component comes first?

Left 王 then right 求.

Tips on stroke order

Minor strokes are written last.

Practise writing the character.

224 入 rù to enter

225 开 kāi to open

TRADITIONAL FORM
開

Character information

This character looks like **roots** going down into the ground, or an **arrow** pointing up into the sky.

Examples

入口 rùkǒu entrance; import
进入 jìnrù to enter

Tips on stroke order

Notice that you write the right stroke before left.

Be careful!

Be careful not to confuse it with 人 rén (person) [1].

Character information

This character combines the **one radical** 一 yī with 廾 (two hands).

Examples

开门 kāimén to open the door; to be open for business
开灯 kāidēng to turn on the light
开车 kāichē to drive
开心 kāixīn happy

More about radicals

You can read about the **one** radical 一 yī by turning back to character [26].

Lost in simplification

The traditional form represents a person (开) holding a door open (門 mén).

• •

Practise writing the character.

• •

Practise writing the character.

Examples
见面 jiànmiàn to meet
听见 tīngjiàn to hear
再见 zàijiàn goodbye

More about radicals
The **see radical** 见 jiàn is associated with
sight. It appears in 观 guān (to look at)
and 觉 jué (to feel; to be aware).

More about phonetics
见 jiàn functions as a **phonetic** in 现 xiàn
(present).

Lost in simplification
The traditional form represents a **person**
(儿 ér) using their **eyes** (目 mù).

Practise writing the character.

Character information
Looks like a **plant** () growing out of a
container ().

Examples
出国 chūguó to go abroad
出发 chūfā to set out (depart) on
 a journey
出生 chūshēng to be born
出租车 chūzūchē taxi

More about radicals
You can read about the **container radical**
by turning back to character [193].

Practise writing the character.

228 叫 jiào to shout; to call

Character information

This character combines the **mouth radical** 口 kǒu to indicate meaning, with the **phonetic** 丩 jiū (twisted vines) to indicate sound.

Examples

叫喊 jiàohǎn to yell
叫做 jiàozuò to be called

More about radicals

You can read about the **mouth radical** 口 kǒu by turning back to character [3].

Good to know!

To say **my name is…**, use the phrase 我叫… Wǒ jiào…

Which component comes first?

Left 口 then right 丩.

● ●

Practise writing the character.

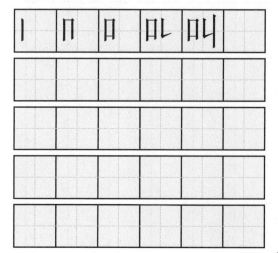

229 打 dǎ to hit

Character information

This character represents a **nail** (丁 dīng) being struck by **hand** (手 shǒu).

Examples

打人 dǎrén to hit somebody
打电话 dǎ diànhuà to make a phone call
打网球 dǎ wǎngqiú to play tennis
打开 dǎkāi to open; to turn on

More about radicals

You can read about the **hand radical** 扌 by turning back to character [4].

Good to know!

When you use your hands or a racquet to **play a ball sport**, use the verb 打 dǎ. However, because you use your feet to play football, you say 踢足球 tī zúqiú, which literally means **kick football**.

Which component comes first?

Left 扌 then right 丁.

● ●

Practise writing the character.

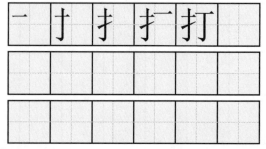

230 生

shēng
to give birth

Character information

This character represents a **plant** (屮) growing out of the **ground** (土 tǔ).

Examples

生孩子 shēng háizi to have a baby
生病 shēngbìng to get ill
生气 shēngqì to get angry
生日 shēngrì birthday
学生 xuéshēng student

More about radicals

You can read about the **slash radical** 丿 by turning back to character [11].

More about phonetics

生 shēng functions as a **phonetic** in 星 xīng (week) [49].

Tips on stroke order

Horizontal strokes are written before the vertical strokes. Bottom horizontal strokes are written last.

Practise writing the character.

231

用 yòng
to use

232

对 duì
to face;
correct

TRADITIONAL FORM

對

Examples

用餐　yòngcān　to have a meal

用功　yònggōng　hardworking

没用　méiyòng　useless

More about radicals

The **use radical** 用 yòng is extremely rare.

More about phonetics

用 yòng functions as a **phonetic** in 拥 yōng (to embrace).

Tips on stroke order

Enclosing strokes are written before enclosed strokes.

Be careful!

Be careful not to confuse it with the **field radical** 田 tián.

Character information

This character combines the **right hand radical** 又 yòu (again) with 寸 cùn (inch).

Examples

对面　duìmiàn　opposite

面对面　miànduìmiàn　face-to-face

对不起　duìbuqǐ　to be sorry

对象　duìxiàng　partner

More about radicals

The **right hand radical** 又 yòu (again) is sometimes associated with hand movement. It appears in 欢 huān (happy) [235], 叉 chā (fork) and 取 qǔ (take).

Good to know!

对 duì means **yes** or **correct**, when you are agreeing with what somebody is saying.

Be careful!

Be careful not to confuse it with huān 欢 (happy) [235].

Practise writing the character.

Practise writing the character.

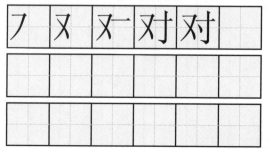

Character information
This character combines the **divide radical** ᠈᠆ with 天 tiān (day).

Examples
关灯　guāndēng　to turn off the light
关门　guānmén　to close the door
关系　guānxì　relationship
关心　guānxīn　to be concerned about

More about radicals
You can read about the **divide radical** 八 bā by turning back to character [33].

Lost in simplification
The traditional form uses the **door radical** 門 mén with a rare phonetic.

Which component comes first?
Upper ᠈᠆ then lower 天.

· ·

Practise writing the character.

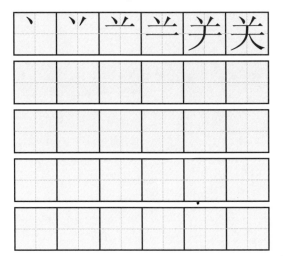

Character information
This character represents a **person** (口 kǒu) coming to the **door** (门 mén).

Examples
问题　wèntí　question; problem
疑问　yíwèn　doubt

More about phonetics
You can read more about the 门 mén **phonetic** by turning back to character [164].

Good to know!
请问 qǐng wèn is a polite way to say **excuse me** before asking a question.

Which component comes first?
Outer 门 then inner 口.

Be careful!
Be careful not to confuse it with 间 jiān [164].

· ·

Practise writing the character.

235

欢

huān
to welcome

TRADITIONAL FORM
歡

Character information
This character combines the **right hand radical** 又 yòu (again) with 欠 qiàn (to owe).

Examples
欢乐 huānlè joyful
欢迎 huānyíng to welcome
喜欢 xǐhuan to like

More about radicals
You can read about the **right hand radical** 又 yòu by turning back to character [232].

More about phonetics
The traditional form uses the **phonetic** 雚 guàn (heron).

Which component comes first?
Left 又 then right 欠.

Tips on stroke order
Left falling strokes are written before right falling strokes.

Be careful!
Be careful not to confuse it with 对 duì (to face; correct) [232].

Practise writing the character.

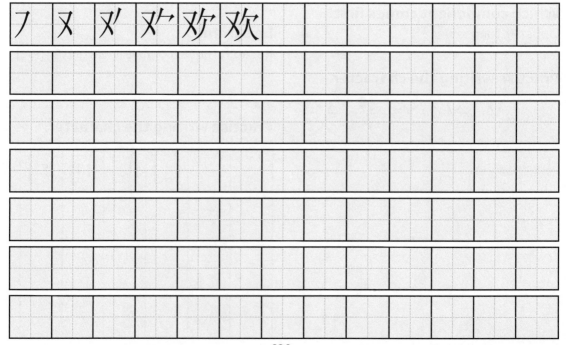

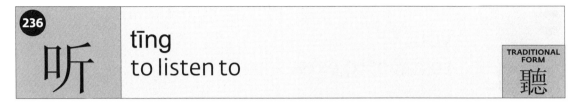

236
听
tīng
to listen to

TRADITIONAL FORM
聽

Character information
This character combines the **mouth radical** 口 kǒu to indicate meaning, with the **phonetic** 斤 jīn (500g) to indicate sound.

Examples
听见 tīngjiàn to hear
听课 tīngkè to attend a lecture
听说 tīngshuō to hear about

More about radicals
You can read about the **mouth radical** 口 kǒu by turning back to character [3].

More about phonetics
斤 jīn (500g [119]) functions as a **phonetic** in 近 jìn (near; close).

Lost in simplification
The traditional form shows a **king** (王 wáng) using **ears** (耳 ěr) to receive **wisdom** (悳 dé).

Which component comes first?
Left 口 then right 斤.

Practise writing the character.

237

有

yǒu
to have; to exist

Character information

This character represented a **hand** (ナ) clutching some **meat** (肉 ròu), which has been modified into the **moon radical** 月 yuè.

Examples

有名 yǒumíng famous; well known
有意思 yǒuyìsi interesting

More about radicals

You can read about the **moon radical** 月 yuè by turning back to character [38].

Which component comes first?

Upper ナ then lower 月.

Tips on stroke order

Enclosing strokes are written before enclosed strokes.

Practise writing the character.

一 ナ 冇 冇 有 有

238

没 méi
to not have; not

TRADITIONAL FORM
没

Character information
This character represents a person being drowned in **water** (氵).

Examples
没关系 méiguānxi it doesn't matter
没有 méiyǒu to not have

More about radicals
You can read about the **water radical** 氵 by turning back to character [130].

Which component comes first?
Left 氵 then right (几 then 又).

Tips on stroke order
Left falling strokes are written before right falling strokes.

Practise writing the character.

basics

239
拉 lā
to pull

Character information
This character combines the **hand radical** 扌 to indicate meaning, with the **phonetic** 立 lì (to stand).

Examples
拉开门 lākāi mén to (pull) open the door
拉货 lāhuò to transport goods
拉小提琴 lā xiǎotíqín to play the violin

More about radicals
You can read about the **hand radical** 扌 by turning back to character [4].

Good to know!
Look out for this character on doors, so you know whether to push or **pull**!

Which component comes first?
Left 扌 then right 立.

Tips on stroke order
Bottom horizontal strokes are written last.

Be careful!
Be careful not to confuse it with 位 wèi (location) [10].

Practise writing the character.

240

shì
to be; yes

Character information

This character represents the **sun** (日 rì) shining on something **right** or **proper** (正 zhèng). Both components have been modified over time.

More about radicals

You can read about the **sun radical** 日 rì by turning back to character [37].

Good to know!

When **to be** is used with an adjective, 是 shì is omitted: 我很忙。 Wǒ hěn máng. I am very busy.

Which component comes first?

Upper 日 then lower.

Tips on stroke order

Bottom enclosing strokes are written after enclosed strokes.

Practise writing the character.

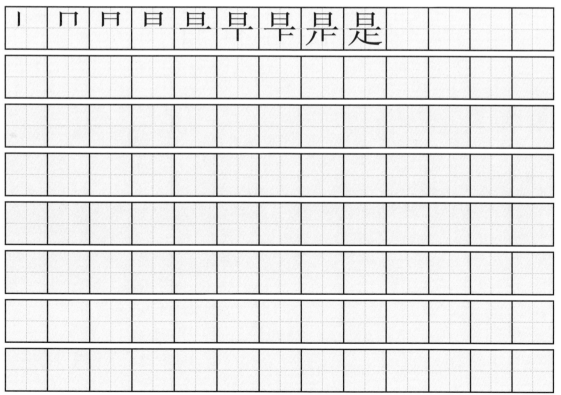

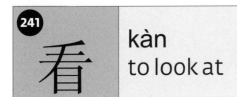

241 看 kàn
to look at

Character information

This character represents a **hand** (手 shǒu) acting as a sunshade over the **eyes** (目 mù).

Examples

看电视 kàn diànshì to watch TV
看小说 kàn xiǎoshuō to read a novel
看病 kànbìng to see the doctor

More about radicals

The **eye radical** 目 mù is associated with **eyes**. It appears in 泪 lèi (tears), 盲 máng (blind), and 睡 shuì (to sleep).

Which component comes first?

Upper 手 then lower 目.

Tips on stroke order

The first stroke is a very shallow left falling stroke.

• •

Practise writing the character.

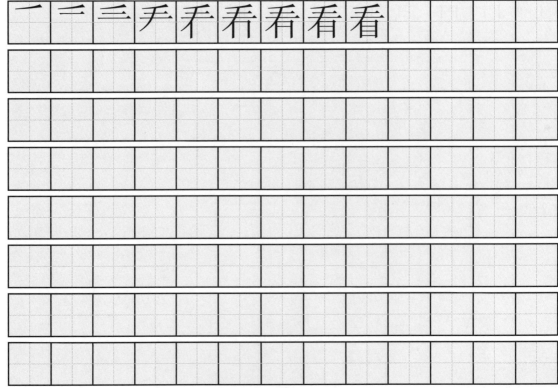

yào
to need; to want

Character information

This character combines the **woman radical** 女 nǚ with 西 xī (west)

Examples

想要 xiǎngyào to want
重要 zhòngyào important
要是 yàoshi if

More about radicals

You can read about the **woman radical** 女 nǚ by turning back to character [2].

Good to know!

要 yào can be used to express something definite: 我明天要上班。Wǒ míngtiān yào shàngbān. I am going to work tomorrow.

- -

Practise writing the character.

一	一	丆	襾	襾	西	要	要	要				

243

说 shuō
to say

TRADITIONAL FORM

說

Character information

This character combines the **speech radical** 讠 to indicate meaning, with 兑 duì (rejoice).

Examples

说话 shuōhuà to talk
小说 xiǎoshuō novel
听说 tīngshuō to hear about

More about radicals

You can read about the **speech radical** 讠 by turning back to character [194].

Lost in simplification

The traditional form uses the unmodified **speech radical** 言 yán.

Which component comes first?

Left 讠 then right 兑.

Practise writing the character.

244

爱

ài
to love

TRADITIONAL FORM

愛

Character information

This character represents a **hand** (⺥) keeping hold of a **friend** (友 yǒu).

Examples

爱好 àihào hobby
爱情 àiqíng love
爱上网 ài shàngwǎng to enjoy surfing the net
可爱 kě'ài adorable

More about radicals

The **claw radical** ⺥ (modified from 爪 zhuǎ) is associated with **hand actions**. It appears in 采 cǎi (to pick; to pluck) and 爬 pá (to climb).

Lost in simplification

If you look closely in the centre of the traditional form, you will find a **heart** 心 xīn.

Which component comes first?

Upper ⺥, centre 冖 then lower 友.

Tips on stroke order

Notice that the first stroke at the top is a very shallow right-to-left falling stroke.

Practise writing the character.

245

能

néng
to be able

Character information

Reflecting its original meaning, this character looks like a **bear**, with a **head** (厶) **body** (月) and **paws** (匕).

Examples

能够 nénggòu to be able
能力 nénglì ability
可能 kěnéng maybe

More about radicals

The **private radical** 厶 sī appears in other characters such as 去 qù (to go) [83].

Good to know!

能 néng can also be used to express being able to do something because you have been granted permission: 你能借我的照相机。 Nǐ néng jiè wǒ de zhàoxiàngjī. You can borrow my camera.

Practise writing the character.

246

请

qǐng
to ask; to invite

TRADITIONAL FORM
請

Character information

This character combines the **speech radical** 讠 to indicate meaning, with the **phonetic** 青 qīng (blue; green) to indicate sound.

Examples

请假 qǐngjià to ask for leave
请客 qǐngkè to treat guests (e.g. for a meal)
请问 qǐngwèn excuse me (before asking a question)

More about radicals

You can read about the **speech radical** 讠 by turning back to character [194].

More about phonetics

You can read about the **phonetic** 青 qīng by turning back to character [170].

Good to know!

You may see 请勿 qǐngwù on signs, meaning **please do not**. For example: 请勿吸烟. Qǐngwù xīyān. **No smoking**.

Which component comes first?

Left 讠 then right 青.

Be careful!

Be careful not to confuse it with 晴 qíng (sunny) [170].

Practise writing the character.

247

推

tuī
to push

Character information

This character combines the **hand radical** 扌 to indicate meaning, with the **phonetic** 隹 zhuī (type of bird).

Examples

推开门 tuī kāimén to (push) open a door
推荐 tuījiàn to recommend

More about radicals

You can read about the **hand radical** 扌 by turning back to character [4].

More about phonetics

隹 zhuī functions as a **phonetic** in 谁 shéi (who?).

Good to know!

Look out for this character on doors, so you know whether to **push** or pull!

Which component comes first?

Left 扌 then right 隹.

Tips on stroke order

Bottom horizontal strokes are written last.

Practise writing the character.

248

谢

xiè
to thank

TRADITIONAL FORM

謝

Character information

This character combines the **speech radical** 讠 to indicate meaning, with the **phonetic** 射 shè (to shoot) to indicate sound.

Examples

谢谢 xièxie Thank you!
多谢 duōxiè Thanks a lot!

More about radicals

You can read about the **speech radical** 讠 by turning back to character [194].

Which component comes first?

Left 讠 then right (身 then 寸).

Tips on stroke order

Minor strokes are written last.

Practise writing the character.

| 丶 | 讠 | 讠 | 讠 | 讠 | 讠 | 讠 | 讠 | 讠 | 讠 | 谢 | 谢 | |

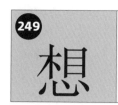

249

想

xiǎng
to think; to feel; to miss

Character information

This character combines the **heart radical** 心 to indicate meaning, with the **phonetic** 相 xiāng (mutual) to indicate sound.

Examples

想办法 xiǎng bànfǎ to think of a way
想法 xiǎngfǎ opinion
想念 xiǎngniàn to miss
回想 huíxiǎng to recall

More about radicals

You can read about the **heart radical** 心 by turning back to character [5].

More about phonetics

相 xiāng functions as a **phonetic** in 箱 xiāng (box; chest).

Which component comes first?

Upper (木 then 目) then lower 心.

Practise writing the character.

一	十	才	木	机	机	相	相	相	相	想	想	想

250

禁

jìn
to prohibit

Character information

This character combines the **sign radical** 示 shì to indicate meaning, with the **phonetic** 林 lín (wood) to indicate sound.

Examples

禁止入内 jìnzhǐ rùnèi no entry
禁止吸烟 jìnzhǐ xīyān no smoking
禁止游泳 jìnzhǐ yóuyǒng no swimming

More about radicals

You can read about the **sign radical** 示 shì by turning back to character [95].

More about phonetics

林 lín functions as a **phonetic** in 淋 lín (to pour; to drench).

Good to know!

When you see this character on a sign, it is asking people to refrain from doing something. See the examples.

Which component comes first?

Upper 林 then lower 示.

Tips on stroke order

Centre strokes are written before outside strokes.

Practise writing the character.

235

Pinyin index

This index lists all of the 250 characters according to the way the sound is written using the Romanized Pinyin system. The ordering is alphabetical, and where the pronunciation of several characters share the same Pinyin spelling, first tones come before second tones, and so on. The index lists the Pinyin, simplified character, English meaning, and the character number in the book.

Pinyin	Chinese Simplified	English	No.
ài	爱	to love	244
ba	吧	auxiliary word	110
bà	爸	father	20
bā	八	eight	33
bái	白	white	204
bàn	半	half	42
běi	北	north	64
bēi	杯	cup; glass	159
biān	边	side	63
bù	不	no	210
cài	菜	vegetable	143
cān	餐	meal	137
cè	厕	toilet	112
chá	茶	tea	142
chàng	唱	to sing	200
chǎo	炒	to stir-fry	135
chāo	超	to exceed; super	127
chē	车	vehicle	91
chéng	城	town; city	69
chī	吃	to eat	128
chù	处	place	92
chū	出	to go out	227
chuáng	床	bed	166
chūn	春	spring	199
cún	存	to exist	85
dà	大	big	213
dǎ	打	to hit	229
dào	到	to arrive; to go	89
dēng	登	to go up	106
dēng	灯	light	190
dì	弟	younger brother	21
dì	地	land	68
diàn	店	shop	122
diàn	电	electricity	221
diǎn	点	o'clock; dot; drop	39
dōng	东	east	65
dòu	豆	bean	146
dù	度	degree	173
dū; dōu	都	city; all	72
duì	对	to face; correct	232
èr	二	two	27

Pinyin	Chinese Simplified	English	No.
fàn	饭	meal; food	138
fáng	房	house; room	165
fēi	飞	to fly	103
fēn	分	to divide; minute	41
fēng	风	wind	168
gǎng	港	harbour	81
gē	哥	elder brother	18
gē	歌	song	201
gōng	公	public	107
gōng	宫	palace	195
gǔ	古	ancient	180
guǎn	馆	place	115
guān	关	to close	233
guì	贵	expensive	124
guó	国	country	75
guō	锅	pot	160
hái	孩	child	24
hǎi	海	sea	82
hàn	汉	the Han people	182
hǎo	好	good	215
hé	河	river	79
hē	喝	to drink	129
hēi	黑	black; dark	208
hóng	红	red	205
hòu	后	behind	62
hú	湖	lake	80
huà	画	to paint	193
huān	欢	to welcome	235
huáng	黄	yellow	207
hūn	婚	marriage; to marry	16
huǒ	火	fire	220
jì	际	border	105
jī	机	machine	104
jī	鸡	chicken	148
jiā	家	family; home	25
jiàn	见	to see	226
jiān	间	room	164
jiāng	江	river	78
jiào	教	to teach	198
jiào	叫	to shout; to call	228
jié	节	joint; festival	184

Pinyin	Chinese Simplified	English	No.
jiě	姐	elder sister	15
jiē	街	street	116
jìn	禁	to prohibit	250
jīn	今	today	52
jīn	斤	unit of weight (equal to 500g); measure word	119
jīng	京	capital	71
jiǔ	九	nine	34
jiǔ	酒	alcohol	132
jú	局	department; office	111
jù	剧	drama	197
kāi	开	to open	225
kàn	看	to look at	241
kǎo	烤	to roast	136
kè	客	visitor	93
kǒng	孔	opening; family name	179
kǒu	口	mouth	3
kuài	快	fast	157
kuài	筷	chopsticks	158
là	辣	hot	155
lā	拉	to pull	239
lái	来	to come	87
lán	蓝	blue	209
lǎo	老	old	216
lěng	冷	cold	171
lí	梨	pear	152
liáng	凉	cool	156
liǎng	两	two	36
lín	林	wood; forest; family name	77
liù	六	six	31
lóng	龙	dragon	186
lù	路	road	117
lǜ	绿	green	206
lǚ	旅	to travel	90
má	麻	hemp; numb	154
mā	妈	mum	13
mài	卖	to sell	121
mǎi	买	to buy	120
méi	没	to not have; not	238
mèi	妹	younger sister	14
měi	美	beautiful	217
mǐ	米	rice; metre	144
miàn	面	surface; flour	147
míng	名	name	17
míng	明	bright	53

Pinyin	Chinese Simplified	English	No.
nǎi	奶	grandmother; milk	12
nán	男	male	7
nán	南	south	66
nèi	内	inside	58
néng	能	to be able	245
nǐ	你	you	8
nián	年	year	51
nǚ	女	woman	2
péng	朋	friend	23
piào	票	ticket	95
pǐn	品	article	123
píng	苹	apple	140
pù	铺	plank bed; berth	102
qì	气	gas; air	167
qī	七	seven	32
qī	期	period of time	50
qián	前	front	61
qián	钱	money	125
qié	茄	aubergine	141
qíng	晴	sunny	170
qǐng	请	to ask; to invite	246
qiú	球	ball	223
qù	去	to go	83
rè	热	heat; hot	172
rén	人	person	1
rì	日	sun; day	37
ròu	肉	meat	145
rù	入	to enter	224
ruǎn	软	soft	100
sān	三	three	28
shān	山	mountain	76
shàng	上	up; on	54
shāng	商	to discuss; commerce	126
shěng	省	province; to save	73
shēng	生	to give birth	230
shí	十	ten	35
shí	时	hour; time	47
shì	市	city; market	70
shì	室	room	94
shì	是	to be; yes	240
shī	诗	poetry	194
shǒu	手	hand; expert	4
shù	术	art; skill	181
shū	书	book	177
shuǐ	水	water	130
shuō	说	to say	243
sì	四	four	29

Pinyin index

Pinyin	Chinese Simplified	English	No.
sì	寺	temple; mosque	189
tā	他	he	9
tài	太	too	211
téng	疼	sore; painful	218
tiān	天	day	46
tiě	铁	iron (metal)	101
tīng	听	to listen to	236
tuī	推	to push	247
wài	外	outside	59
wǎn	晚	evening	45
wǎn	碗	bowl	161
wáng	王	king; family name	6
wǎng	网	net	108
wèi	位	location; measure word	10
wén	文	culture	178
wèn	问	to ask	234
wǒ	我	I; me	11
wù	雾	fog	176
wǔ	五	five	30
wǔ	午	midday	44
xǐ	洗	to wash	131
xī	西	west	67
xià	下	under; off	55
xiā	虾	shrimp	151
xián	咸	salted	153
xiǎng	想	to think; to feel; to miss	249
xiǎo	小	small	214
xiè	谢	to thank	248
xiě	写	to write	187
xīn	心	heart	5
xīn	新	new	219
xíng	行	to walk; to travel	84
xīng	星	star	49
xué	学	to study	192
xuě	雪	snow	175
yā	鸭	duck	149
yǎn	演	to perform	202
yào	药	medicine	222

Pinyin	Chinese Simplified	English	No.
yào	要	to need; to want	242
yé	爷	grandfather	19
yī	一	one	26
yī	医	doctor; medicine	109
yín	银	silver	114
yǐn	饮	to drink	139
yìng	硬	hard	99
yǐng	影	shadow; film	203
yòng	用	to use	231
yòu	右	right	57
yǒu	有	to have; to exist	237
yú	鱼	fish	150
yù	玉	jade	183
yǔ	雨	rain	174
yǔ	语	language	196
yuán	元	first; measure word	118
yuán	员	employee	162
yuàn	院	courtyard	113
yuè	月	moon	38
yuè; lè	乐	music; happy	185
yún	云	cloud	169
zài	再	again	212
zǎo	早	morning; early	43
zhàn	站	to stand	96
zhāng	张	family name; measure word	22
zhào	照	to light up	97
zhēng	蒸	to steam	134
zhǐ	纸	paper	191
zhōng	钟	bell; clock	40
zhōng	中	centre	60
zhōu	周	week; family name	48
zhōu	州	state	74
zhù	住	to live	163
zhǔ	煮	to boil	133
zì	字	character	188
zǒu	走	to walk; to leave	88
zū	租	to hire	98
zuò	坐	to sit; to travel by	86
zuǒ	左	left	56

Radical index

All the characters in the book are listed here in their radical groups. This lets you see at a glance all of the characters which share the same radicals. The radicals are listed according to the number of strokes (so, radicals with one stroke are listed before radicals with two strokes, and so on). A few radicals can be written in more than one way, which means it would be possible to list them in two different places in the index. In these examples, the stroke count for the original form takes precedent. They are:

(4 (3) strokes) 心 (忄) Heart
(4 (3) strokes) 手 (扌) Hand
(4 (3) strokes) 水 (氵) Water
(9 (3) strokes) 食 (饣) Food

(1 stroke) 一 One			
哥	gē	elder brother	18
一	yī	one	26
三	sān	three	28
五	wǔ	five	30
七	qī	seven	32
两	liǎng	two	36
天	tiān	day	46
上	shàng	up; on	54
下	xià	under; off	55
东	dōng	east	65
来	lái	to come	87
面	miàn	surface; flour	147
不	bù	no	210
再	zài	again	212
开	kāi	to open	225
(1 stroke) 丨 Line			
内	nèi	inside	58
中	zhōng	centre	60
北	běi	north	64
肉	ròu	meat	145
(1 stroke) 丶 Dot			
半	bàn	half	42
学	xué	to study	192
(1 stroke) 丿 Slash			
我	wǒ	I; me	11
九	jiǔ	nine	34
午	wǔ	midday	44
周	zhōu	week; family name	48
年	nián	year	51
后	hòu	behind	62
州	zhōu	state	74
乐	yuè; lè	music; happy	185
生	shēng	to give birth	230
(1 stroke) 乙 (乁 / 乛 / 乚) Second			
飞	fēi	to fly	103

买	mǎi	to buy	120
书	shū	book	177
孔	kǒng	opening; family name	179
(2 strokes) 二 Two			
二	èr	two	27
元	yuán	first; measure word	118
云	yún	cloud	169
(2 strokes) 亠 Lid			
六	liù	six	31
市	shì	city; market	70
京	jīng	capital	71
商	shāng	to discuss; commerce	126
(2 strokes) 人 (亻) Human			
人	rén	person	1
今	jīn	today	52
入	rù	to enter	224
你	nǐ	you	8
他	tā	he	9
位	wèi	location; measure word	10
住	zhù	to live	163
(2 strokes) 八 Divide			
弟	dì	younger brother	21
八	bā	eight	33
分	fēn	to divide; minute	41
公	gōng	public	107
黄	huáng	yellow	207
关	guān	to close	233
(2 strokes) 冂 Open country			
网	wǎng	net	108
(2 strokes) 冖 Cover			
写	xiě	to write	187
(2 strokes) 冫 Ice			
凉	liáng	cool	156
冷	lěng	cold	171
(2 strokes) 凵 Container			
画	huà	to paint	193

出	chū	to go out	227
(2 strokes)	刂	**Knife**	
前	qián	front	61
到	dào	to arrive; to go	89
剧	jù	drama	197
(2 strokes)	力	**Power**	
男	nán	male	7
(2 strokes)	匚	**Right open box**	
医	yī	doctor; medicine	109
(2 strokes)	十	**Cross**	
十	shí	ten	35
南	nán	south	66
卖	mài	to sell	121
古	gǔ	ancient	180
(2 strokes)	卜	**Divination**	
外	wài	outside	59
(2 strokes)	厂	**Cliff**	
厕	cè	toilet	112
(2 strokes)	厶	**Private**	
去	qù	to go	83
能	néng	to be able	245
(2 strokes)	又	**Right hand**	
对	duì	to face; correct	232
欢	huān	to welcome	235
(2 strokes)	讠	**Speech**	
诗	shī	poetry	194
语	yǔ	language	196
说	shuō	to say	243
请	qǐng	to ask; to invite	246
谢	xiè	to thank	248
(2 strokes)	阝 (right)	**Capital**	
都	dū; dōu	city; all	72
(2 strokes)	阝 (left)	**Mound**	
际	jì	border	105
院	yuàn	courtyard	113
(3 strokes)	口	**Mouth**	
口	kǒu	mouth	3
名	míng	name	17
右	yòu	right	57
吧	ba	auxiliary word	110
品	pǐn	article	123
吃	chī	to eat	128
喝	hē	to drink	129
咸	xián	salted	153
员	yuán	employee	162
唱	chàng	to sing	200
叫	jiào	to shout; to call	228
听	tīng	to listen to	236

(3 strokes)	囗	**Enclosure**	
四	sì	four	29
国	guó	country	75
(3 strokes)	土	**Earth**	
地	dì	land	68
城	chéng	town; city	69
坐	zuò	to sit; to travel by	86
寺	sì	temple; mosque	189
(3 strokes)	夂	**Go**	
处	chù	place	92
(3 strokes)	大	**Big**	
太	tài	too	211
大	dà	big	213
美	měi	beautiful	217
(3 strokes)	女	**Woman**	
女	nǚ	woman	2
奶	nǎi	grandmother; milk	12
妈	mā	mum	13
妹	mèi	younger sister	14
姐	jiě	elder sister	15
婚	hūn	marriage; to marry	16
好	hǎo	good	215
要	yào	to need; to want	242
(3 strokes)	子	**Child**	
孩	hái	child	24
存	cún	to exist	85
(3 strokes)	宀	**Roof**	
家	jiā	family; home	25
客	kè	visitor	93
室	shì	room	94
字	zì	character	188
宫	gōng	palace	195
(3 strokes)	小	**Small**	
省	shěng	province; to save	73
小	xiǎo	small	214
(3 strokes)	尸	**Corpse**	
局	jú	department; office	111
(3 strokes)	山	**Mountain**	
山	shān	mountain	76
(3 strokes)	工	**Work**	
左	zuǒ	left	56
(3 strokes)	广	**Shelter**	
店	diàn	shop	122
麻	má	hemp; numb	154
床	chuáng	bed	166
度	dù	degree	173
(3 strokes)	弓	**Bow**	
张	zhāng	family name; measure word	22

(3 strokes)	彡	Bristle	
影	yǐng	shadow; film	203

(3 strokes)	彳	Step	
行	xíng	to walk; to travel	84
街	jiē	street	116

(3 strokes)	攵	Rap	
教	jiào	to teach	198

(3 strokes)	纟	Silk	
纸	zhǐ	paper	191
红	hóng	red	205
绿	lǜ	green	206

(3 strokes)	艹	Grass	
蒸	zhēng	to steam	134
苹	píng	apple	140
茄	qié	aubergine	141
茶	chá	tea	142
菜	cài	vegetable	143
节	jié	joint; festival	184
蓝	lán	blue	209
药	yào	medicine	222

(3 strokes)	辶	Walk	
边	biān	side	63

(3 strokes)	门	Gate	
间	jiān	room	164
问	wèn	to ask	234

(4 strokes)	文	Script	
文	wén	culture	178

(4 strokes)	斤	Axe	
斤	jīn	unit of weight (equal to 500g); measure word	119
新	xīn	new	219

(4 strokes)	方	Square	
旅	lǚ	to travel	90
房	fáng	house; room	165

(4 strokes)	日	Sun	
日	rì	sun; day	37
早	zǎo	morning; early	43
晚	wǎn	evening	45
时	shí	hour; time	47
星	xīng	star	49
明	míng	bright	53
晴	qíng	sunny	170
春	chūn	spring	199
是	shì	to be; yes	240

(4 strokes)	月	Moon	
朋	péng	friend	23
月	yuè	moon	38
期	qī	period of time	50
有	yǒu	to have; to exist	237

(4 strokes)	木	Wood	
林	lín	wood; forest; family name	77
机	jī	machine	104
梨	lí	pear	152
杯	bēi	cup; glass	159
术	shù	art; skill	181

(4 strokes)	欠	Yawn	
歌	gē	song	201

(4 strokes)	气	Air	
气	qì	gas; air	167

(4 strokes)	火 (灬)	Fire	
炒	chǎo	to stir-fry	135
烤	kǎo	to roast	136
灯	dēng	light	190
火	huǒ	fire	220
点	diǎn	o'clock; dot; drop	39
照	zhào	to light up	97
煮	zhǔ	to boil	133
热	rè	heat; hot	172

(4 strokes)	爪 (爫)	Claw	
爱	ài	to love	244

(4 strokes)	父	Father	
爷	yé	grandfather	19
爸	bà	father	20

(4 strokes)	王	King	
王	wáng	king; family name	6
玉	yù	jade	183
球	qiú	ball	223

(4 strokes)	见	See	
见	jiàn	to see	226

(4 strokes)	贝	Shell	
贵	guì	expensive	124

(4 strokes)	车	Vehicle	
车	chē	vehicle	91
软	ruǎn	soft	100

(4 strokes)	风	Wind	
风	fēng	wind	168

(4 (3) strokes)	心 (忄)	Heart	
心	xīn	heart	5
想	xiǎng	to think; to feel; to miss	249
快	kuài	fast	157

(4 (3) strokes)	手 (扌)	Hand	
手	shǒu	hand; expert	4
打	dǎ	to hit	229
拉	lā	to pull	239
推	tuī	to push	247

(4 (3) strokes) 水 (氵) Water			
水	shuǐ	water	130
江	jiāng	river	78
河	hé	river	79
湖	hú	lake	80
港	gǎng	harbour	81
海	hǎi	sea	82
洗	xǐ	to wash	131
酒	jiǔ	alcohol	132
汉	hàn	the Han people	182
演	yǎn	to perform	202
没	méi	to not have; not	238

(5 strokes) 用 Use			
用	yòng	to use	231

(5 strokes) 田 Field			
电	diàn	electricity	221

(5 strokes) 疒 Sickness			
疼	téng	sore; painful	218

(5 strokes) 白 White			
白	bái	white	204

(5 strokes) 目 Eye			
看	kàn	to look at	241

(5 strokes) 石 Stone			
硬	yìng	hard	99
碗	wǎn	bowl	161

(5 strokes) 示 Sign			
票	piào	ticket	95
禁	jìn	to prohibit	250

(5 strokes) 禾 Grain			
租	zū	to hire	98

(5 strokes) 立 Stand			
站	zhàn	to stand	96

(5 strokes) 钅 Metal			
钟	zhōng	bell; clock	40
铁	tiě	iron (metal)	101
铺	pù	plank bed; berth	102
银	yín	silver	114
钱	qián	money	125
锅	guō	pot	160

(5 strokes) 鸟 Bird			
鸡	jī	chicken	148
鸭	yā	duck	149

(5 strokes) 龙 Dragon			
龙	lóng	dragon	186

(6 strokes) ⺮ Bamboo			
筷	kuài	chopsticks	158

(6 strokes) 米 Rice			
米	mǐ	rice; metre	144

(6 strokes) 老 Old			
老	lǎo	old	216

(6 strokes) 虫 Insect			
虾	xiā	shrimp	151

(6 strokes) 西 / 覀 West			
西	xī	west	67

(7 strokes) 豆 Bean			
登	dēng	to go up	106
豆	dòu	bean	146

(7 strokes) 走 Run			
走	zǒu	to walk; to leave	88
超	chāo	to exceed; super	127

(7 strokes) 足 Foot			
路	lù	road	117

(7 strokes) 辛 Bitter			
辣	là	hot	155

(8 strokes) 雨 Rain			
雨	yǔ	rain	174
雪	xuě	snow	175
雾	wù	fog	176

(8 strokes) 鱼 Fish			
鱼	yú	fish	150

(9 (3) strokes) 食 (饣) Food			
餐	cān	meal	137
馆	guǎn	place	115
饭	fàn	meal; food	138
饮	yǐn	to drink	139

(12 strokes) 黑 Black			
黑	hēi	black; dark	208